Rodin's *Thinker*
and the
Dilemmas of Modern Public Sculpture

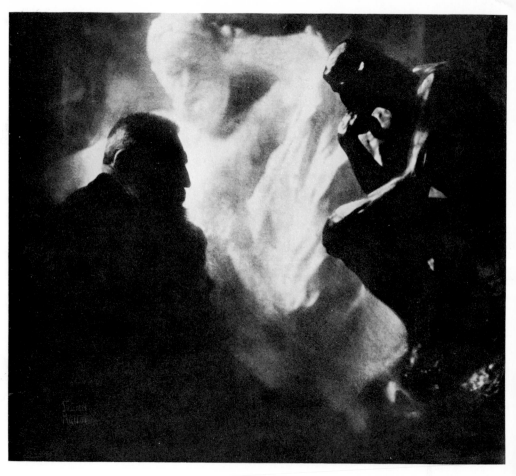

Edward Steichen, *Rodin and "The Thinker"*

Rodin's Thinker and the Dilemmas of Modern Public Sculpture

ALBERT E. ELSEN

YALE UNIVERSITY PRESS
New Haven and London

*Published with assistance from
the Cantor Fitzgerald Foundation.*

Designed by Margaret E.B. Joyner
and set in Palatino type
by Rainsford Type.
Printed in the United States of America by
Murray Printing Company, Westford, Massachusetts.

Library of Congress Cataloging in Publication Data

Elsen, Albert Edward, 1927-
 Rodin's Thinker and the dilemmas of modern public sculpture.

 Bibliography: p.
 1. Rodin, Auguste, 1840-1917. Thinker. 2. Public
sculpture—France—Public opinion. 3. Public opinion—
France. I. Title.
NB533.R7A76 1985 730'.92'4 85-626
ISBN 0-300-03334-6 (alk. paper)
ISBN (pbk) 0-300-03652-3

10 9 8 7 6 5 4 3 2 1

This book is dedicated to those artists and donors who contributed artworks and funds to outdoor sculpture at Stanford University over the last fifteen years.

NATHAN R. CUMMINGS for Henry Moore's *Large Torso: Arch*

JAMES ROSATI for *Inscape*

ARNALDO POMODORO for *Facade* and THE COMMITTEE FOR ART that paid for its bronze casting.

JOSEF ALBERS for donating the design of his *Stanford Wall* whose construction was made possible by MARY MARGARET and HARRY ANDERSON, JUNE CATRON and THE HANCOCK FOUNDATION, THOMAS CONROY, GORDON HAMPTON, the JANSS FAMILY, PHYLLIS and STUART MOLDAW

RICHARD and JANE LANG for Sandy Calder's *Le Faucon*

NORMA and CARL DJERASSI for Arnaldo Pomodoro's *Cube* given in memory of their daughter Pamela

DON THAYER, MR. and MRS. EDWIN CLOCK, PEGGY and WILLIAM LOWE, and an anonymous donor for Dimitri Hadzi's *Pillars of Hercules, III*

JOANNE and JULIAN GANZ and the NATIONAL ENDOWMENT FOR THE ARTS for Kenneth Snelson's *Mozart I*

MADELEINE HAAS RUSSELL for Joan Miro's *Oiseau*

The ANNA BING FUND, JOANNE and JULIAN GANZ, and an anonymous donor for Bruce Beasley's *Vanguard*

DON and DORIS FISHER for their Sculpture Loan Fund.

Contents

Illustrations

Frontispiece: Edward Steichen, *Rodin and "The Thinker,"* 1902. (Photo Musée Rodin)

1 Rodin, *The Thinker*, bronze, 1880, 28 × 14 × 19", B. G. Cantor Collections. Frontal view. (Photo Lynn Diane De Marco)

2 *The Thinker*, detail of the face. (Photo Lynn Diane De Marco)

3 *The Thinker*, detail of the groin area. (Photo Lynn Diane De Marco)

4 *The Thinker*, front view of the statue's right profile. (Photo Lynn Diane De Marco)

5 *The Thinker*, view of the statue's right profile. (Photo Lynn Diane De Marco)

6 *The Thinker*, rear view of the statue's right profile. (Photo Lynn Diane De Marco)

7 *The Thinker*, back view. (Photo Lynn Diane De Marco)

8 *The Thinker*, detail of the back. (Photo Lynn Diane De Marco)

9 *The Thinker*, detail of the upper back. (Photo Lynn Diane De Marco)

10 *The Thinker*, view of the statue's left profile. (Photo Lynn Diane De Marco)

11 *The Thinker*, front view of the statue's left profile. (Photo Lynn Diane De Marco)

12 Jean Goujon and assistants, relief sculpture on the Louvre, sixteenth century, pavilion of Henry II.

13 Apollonios, *The Belvedere Torso*, fragment from the late Roman Republic, the Vatican.

14 Rodin, *Trophy of the Arts*, 1874, Palais des Academies, Brussels. (Photo Steve McGough)

15 Rodin, Study of a seated or crouching male torso, terra-cotta, date unknown, Musée Rodin, Meudon. Rear view. (Author's photo)

16 Study of a seated or crouching male torso, front view. (Author's photo)

17 Rodin, *Industry*, from the now destroyed monument to J. F. Loos, 1874–76, Antwerp. (Photo courtesy Albert Aldaheff)

18 Rodin, *The Sailor*, from the monument to J. F. Loos. (Photo courtesy Albert Aldaheff)

40 Detail of *The Gates of Hell* showing *The Thinker*. (Photo Bill Schaefer)

41 *The Thinker* in *The Gates of Hell*, view from below. (Photo Bill Schaefer)

42 Rodin, self-portrait in the lower right jamb of *The Gates of Hell*. (Photo Bill Schaefer)

43 Henri Lebossé effecting the montage of the enlarged version of Rodin's *Ugolino and His Children*. (Photo courtesy of the Philadelphia Museum of Art: Rodin archives at the Marion Angell Boyer and Francis Boyer Library.)

44 Three views of a present-day sculptural reproducer working on one of the same machines used by Lebossé to enlarge Rodin's *Thinker*.

45 Rodin, *Head of The Thinker*, plaster, enlarged by Lebossé, Musée Rodin. (Author's photo)

46 Constantin Meunier, *The Miner*, bronze, the Salon of 1904. (Photo from Paul Vitry, "La Sculpture aux Salons," *Art et Décoration*, July–December 1904, p. 28)

47 Subscription form published by *Les Arts de la Vie* for *Le Penseur*.

48 *The Thinker* installed before the Pantheon on the pedestal made by Courtot with the inscription designed by Rodin. (Photo Roger Viollet)

49 *The Thinker* on its original pedestal, installed in the garden of the Musée Rodin. (Photo Kenneth Snelson)

50 The dedication of *The Thinker* before the Pantheon in Paris, April 21, 1906. (Photo courtesy The Museum of Modern Art, NYC.)

51 Rodin, *Thought*, marble, 1886, photographed in Rodin's studio in 1900 with *The Gates of Hell* in the background.

52 *The Thinker* installed before the Pantheon. (Photo Lucien Napoleon Brunswig, courtesy of Mrs. George Liddle)

53 Paul Dubois, *Military Courage,* from the monument to General Lamoricière, Nantes Cathedral, 1876.

54 *The Thinker* in front of the Cleveland Museum of Art. (Photo Cleveland Museum of Art)

55 *The Thinker* above the grave of Auguste and Rose Rodin at Meudon. (Author's photo)

56 Rodin's funeral, November 24, 1917, Meudon. (Photo Edward Steichen)

Various cartoons and advertisements featuring *The Thinker*, pp. 146–50.

Acknowledgments

My research in the vast archives of the Musée Rodin was greatly aided by my wife, Patricia, whose years of sharing my Rodin studies made her alert to many valuable documents. The fruitful research at the Musée Rodin was made possible by the cooperation of Madame Monique Laurent and her very capable staff, which has organized this wealth of material so that it is usable by scholars. Claudie Judrin, curator of drawings, Helène Pinet, *archiviste*, and Alain Beausire, *documentaliste*, have been particularly helpful. Much encouragement came from B. Gerald Cantor. His curators, Vera Green, Joan Miller, and Susan Zeitlin, contributed much encouragement and information. I am particularly grateful for their assistance in obtaining the photographs of *The Thinker* "in the round." The Cantor Rodin Research Fund at Stanford University provided research funds. Margie Grady and Alex Ross of the Stanford University Art Library are marvelous retrievers of obscure literature. My former and present graduate students Joanne Paradise, Rosalyn F. Jamison, Gerard Koskovich, and John Wetenhall made welcome contributions. My departmental and university colleagues, Professors Jody Maxmin and Michael Jamison, suggested Greek precedents for the dilemmas of modern public sculpture. Doctors William Fielder and Gary Fry made the diagnosis of the biological age of the model for *The Thinker*, and Dr. Fielder's comments on the artistic liberties Rodin took with his subject's anatomy were very helpful. My former colleague Walter Mischel was a provocative audience for trying out ideas. Paul Turner, Michel and Marina Boudard, Elizabeth Gibbs and Olivier Pieron, all of Stanford, helped on important points or at crucial moments. Many friends, notably Kirk and Sam Varnedoe, Robert Campbell, John Hochmann, and Dan Rosenfeld, knowing of my interest in the exploitation of *The Thinker*, contributed advertisements. I would especially like to thank

Boots Liddle for allowing me to make a print of her grandfather's marvelous photograph of *The Thinker* before the Pantheon. Finally, my gratitude goes to Dean Norman Wessells of the School of Humanities and Sciences at Stanford, for making word processors available to so many humanists to expedite our research and writing.

PART ONE

The History of "The Thinker" to 1900

RODIN'S "THINKER" IS AT ONCE THE MOST FAMOUS AND MOST PRIVATE OF public sculptures. Unanswered questions—who is *The Thinker* and what does he think—have encouraged endless interpretation and renewed *The Thinker*'s relevance in successive times and contexts. If Rodin had stated his intentions clearly and without apparent contradiction and had he been consistent about the meaning of the work, it is questionable that *The Thinker* would have become the most well-known sculpture in the world. No other sculpture has so preempted a natural pose. Just to sit with head in hand is to invite identification with the statue; in this sense we see life in terms of art. The many bronze casts of this work and its commercial overexposure have made it, like *The Statue of Liberty*, all but invisible as a work of art.[1] Yet, while in America *The Thinker* "made" Rodin, *The Statue of Liberty* did not do the same for its creator, Frédéric-Auguste Bartholdi, who is today largely unknown.[2]

Reduction of *The Thinker* to a visual cliché may have also discouraged consideration of its history. The serious literature is small in proportion to the statue's importance and renown.[3] Although the sculpture was considered innovative at its creation, its pose and theme have come to be regarded as banal, and yet the apparent banality did not prevent it from being misread. So deceptively simple is the image and so pervasive is its exploitation that

only rarely has the statue's form been closely and rightly read. On at least one occasion even Rodin inaccurately described how he had treated the figure's right hand: "What makes my *Thinker* think is that he thinks not only with his brain, his distended nostrils, and compressed lips, but with every muscle of his arms, back and legs, with his *clenched fist* and gripping toes." (Emphasis mine.)[4] A close look at *The Thinker* is in order.

"The Thinker" as a Work of Art

The Thinker is a fully mature, muscular male nude, the model for which was probably between the ages of forty and forty-five, roughly that of Rodin, who was forty years of age when he made this sculpture in its original size of twenty-seven inches[5] (figs. 1–11). The figure is seated upon a rock that has been modeled and cut to accord with his pose and form. His chin rests on the back of his open right hand, from the knuckles to the first joint, in such a way that the mouth is hidden. He bends forward to allow his right elbow to rest upon his left thigh just above the knee. The left hand is relaxed, and his wrist is posed on the left kneecap. The dropping of the shoulder and crossing of the right arm, seen from the side, deepen the sense of cogitation and impart the impression that the man is figuratively putting his back into the process of thought (fig. 4). From all but a head-on view, the position of the man's right knee and left hand help to conceal the genitals, like a baseball catcher masking his signs with the gloved hand (fig. 1). Rodin treated the genitals in a summary manner so that the figure appears endowed with a large penis but has no clearly defined scrotum (fig. 3). The feet are set near one another, and the left foot is positioned slightly higher because the left thigh is raised to meet the right elbow. Although not dictated by the position of the knees, the convergence of the feet sets up diagonal movements in the lower legs.

1 *The Thinker*, bronze, 1880, 28 × 14 × 19",
B. G. Cantor Collections. Front view.

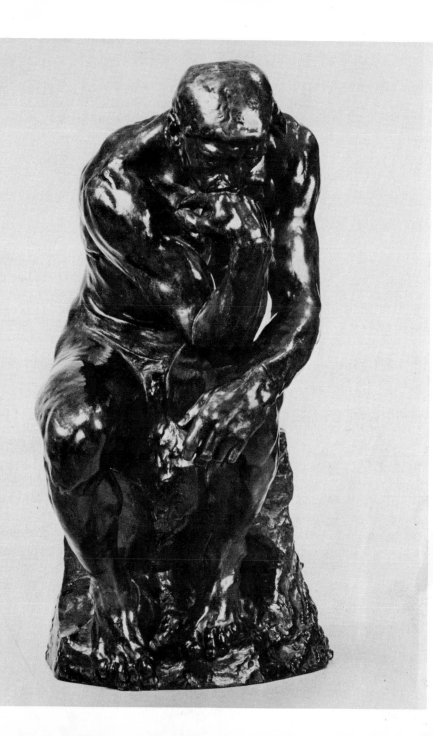

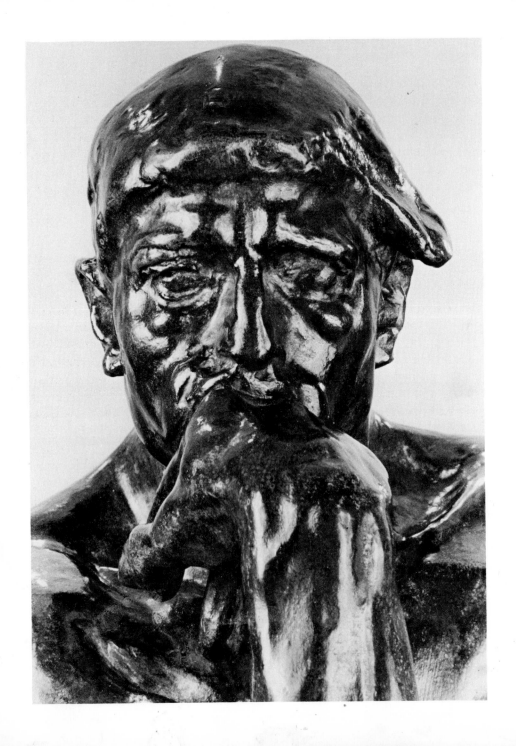

The Thinker's whole body is tense, not only because of the exertion of the crossover gesture of the right arm, but also because the legs and feet seem to brace against and grip the rock. (The curvature of the toes that evokes the gripping action could also have been caused in a mature male model by his shoes.) His head is covered by a thick cap of hair, which appears permanently smoothed as if by the prolonged wearing of headgear. What looks like a flap above the man's left ear is part of his hair. The mature face supports the reading of the model's age as being forty or over. His expression is not angry, sad, or troubled, but suggests deep inner absorption that has caused contraction of the heavy brows (fig. 2). The eyes lack irises, so there is no sense of optical focus on the external world. Anatomically, all of the extremities seem slightly large in proportion to the body. It is the large hands that signal interesting dualities in the sculpture and the man himself.

Possessed of a lean, rugged physique, *The Thinker* manifests a certain grace through the unusual but expressive rotation of the right shoulder and arm, and the hands. Most people think they see the right hand as knotted into a fist, but its fingers are actually extended and turned back toward the body to support the head, creating a gesture of self-address. The relaxed position of the man's left hand contrasts with the pervasive tension in the body and suggests the presence of more than one emotional state. Rodin has created an image of action in repose.

Rodin's modeling is close to being anatomically correct, but it is not literal. From the front the most obvious departure from his living subject is the treatment of the hair, which has an almost helmet-like smoothness, except around the edges. Portions of the upper and lower back received a rough patching instead of being carried to the definition found in the areas of the body that are more easily seen from the front and sides (figs. 8, 9). Within the big planes formed by the large muscles considerable nuance is created by roughening of the surface, which provides a slight halo of light and a sense of atmosphere to the silhouette that contrasts with the sharp cut-out effect

2 Detail of the face.

that Rodin detested in his contemporaries' public statues.[6] The liberties he took with his model's anatomy can be seen in the treatment of the figure's hips; the hip joints are abnormally distant from the kneecaps. Rodin needed this additional length for a visual and artistic purpose, to allow the knees to project further forward into space in order to better balance the head from the side view. Increasing the length of the upper leg in proportion to the lower leg was intended to prevent the impression that the figure was toppling forward. Perhaps to mask this distortion or to achieve a greater sculptural effect, Rodin also introduced a crease along the man's upper right thigh and, above, a cavity near the hip joint that would not be found in the model.

Rodin's anatomical exaggerations were intended to assist the sculpture to "carry" or be visually distinguishable from a distance under widely varied lighting conditions. Serving this purpose are the enlarged extremities and the deeply gouged indentations in the surface that sometimes outline the tensed muscles, notably on either side of the man's right triceps in his upper arm (fig. 4). Rodin knew that in bronze the indentations suggesting flexed muscles would eventually lighten with deposits of dust and patination stains caused by weathering. To preserve the strength of the form over time Rodin, therefore, exaggerated the depths of these passages. In an unsigned article that appeared in *L'Opinion* (June 18, 1908), a reporter noted, "In his garden the master has a *Thinker*. He studies the effect of frost and pigeon droppings [*effets de pigeon*] that seem to him fortuitous 'familiarities.' " Close reading of *The Thinker*'s modeling, then, reveals many anatomically unaccountable touches that call attention to artistic decisions. Only on this basis can we account, for example, for the flap of hair that extends out and down over the man's left ear. Rodin would have been pleased that such devices are not normally noticed in the sculpture.

When seen from the sides, but especially from the front and back, *The Thinker* appears to sit within a cube (figs. 1, 5, 7, 11). This is no coincidence. By bending the figure forward from the waist and lowering the head, Rodin

3 Detail of the groin.

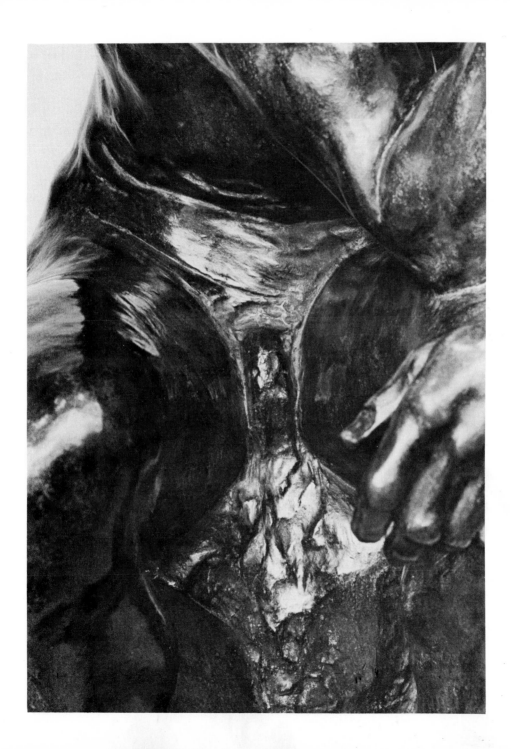

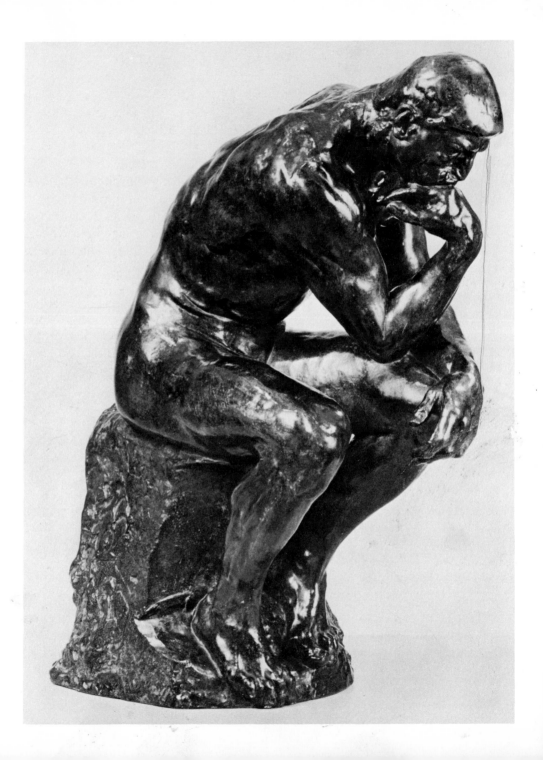

compacted the form and brought the forehead into a vertical line with the left hand, a line that can be read as the frontal plane of the spatial cube. One of the artist's maxims was that "if my sculpture is good it is because it is geometric. . . . cubic truth, not appearance, is the mistress of things."[7] Rodin, who was obsessed with unity, as well as with imparting movement to his figures, found that as long as he could visualize his figures within simple forms, such as the cube, he would achieve harmony and the look of the natural.

Statues of seated male figures had been made many times before, and invariably the subject sits with back erect, head up, and the face fully visible. This arrangement imparts a sense of dignity through good posture and mental alertness. Working within a long and great tradition, Rodin had a compulsion to be original and to rethink problems freshly rather than to memorize solutions. *The Thinker* presented Rodin with the problem of how to make a dynamic sculpture out of a sedentary subject. His answer was to give the human form not just tensed muscles, but a vigorous and expressive architecture. The crossover gesture of the model's right arm helps break the symmetry of the pose by rotating the shoulders counterclockwise and occasioned the projection of muscles and tendons in the side and back, but this is only one aspect of the forceful structure he found for the body. He met the vehement slanted thrust of the upper right arm with the reverse direction of the forearm and the entire length of the man's left arm, which closes off the sculpture to our right. Up and down the sculpture, the limbs play against their opposites, and this is true in terms of the lateral axes of the form. No two paired joints, such as ankles, knees, hips, elbows, and shoulders, lie in planes parallel to the ground. If each pair was connected by a line, the lines would tend to tilt diagonally, but not to be parallel to each other. These tilted axes are countered by the opposing diagonal movement of the man's right arm and the vertical axis formed by the head, hands, and right foot. This vertical axis is not passive, because its components do not lie in the same vertical plane. Despite the quiet pose, all is in emphatic movement.

4 Front view of right profile.

At this stage in his career sculpture for Rodin was more than the "hole" and the "lump"; sculptural drama meant energetic relationships, such as vigorously contrasting axes and movements. Viewed from the right and left sides, for instance, the figure is like an architectural console or bracket that from the top swells outward, then inward, outward again, and down. Rodin loved this architectural form as a model for his figural movement, as well as admiring it in certain of Michelangelo's figures.[8] From the statue's left side, the pose also looks like a question mark (fig. 10).

Sculptors of Rodin's period, and earlier times as well, looked for the *great line* or uninterrupted contour from head to toe that a thoughtful arrangement of the body might elicit. *The Thinker's* haircap was a crucial invention, for it allowed Rodin to smooth out the silhouette of the figure when seen from either side. One of the statue's many great lines visible from the sides begins at the toes and rises upward through the contours of legs and buttocks to the back, over the shoulders and along the neck (figs. 4, 10). The smooth arc of the haircap connects this beautiful extended passage with the more angular in-and-out motion of the forward profile that returns the eye to where its journey began.

Rodin's boldness in attacking conventions of balancing a statue can also be seen from the sides. He extends the head, hands, and knees out into space beyond the line of the feet. The thrust of the big curving back is met and arrested by the implied vertical of the upper extremities. By academic standards of the time, from the sides *The Thinker* was top-heavy and not plumb; he was prone to toppling because the upper portion was not directly over a supporting leg or foot. Circling the statue, the viewer receives different impressions of the figure's relative stability (figs. 5, 6), not unlike *The Walking Man*, who seen this way seems to lose and then recover his balance. Rodin rejected conventional rules for equilibrium and found his own artistic center for the figure in the navel area, around which he asymmetrically disposed the volumes. Artistically as well as anatomically, the area from the bottom of the sternum to the pelvis was pivotal in Rodin's male figure sculpture.

Much of the beauty and expressiveness of this statue stems from the surprisingly intimate relationship of the figure to its support. The rock on

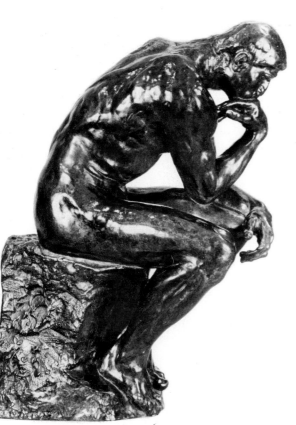

5 View of right profile.

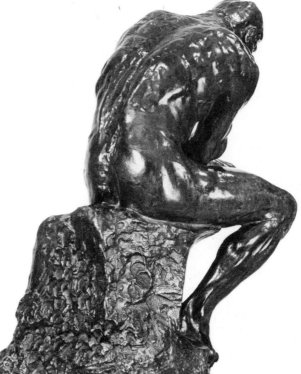

6 Rear view of right profile.

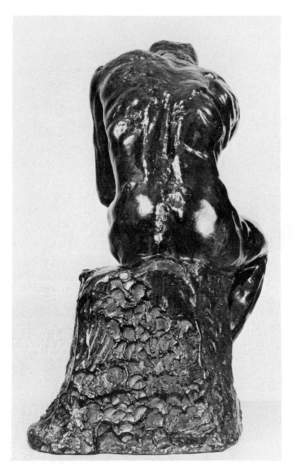

7 Rear view.

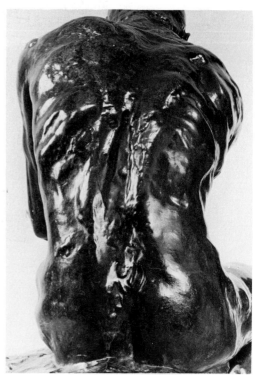

8 Detail of the back.

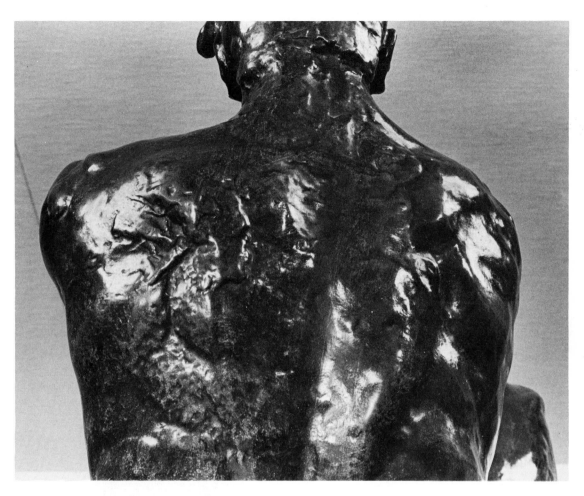

9 Detail of the upper back.

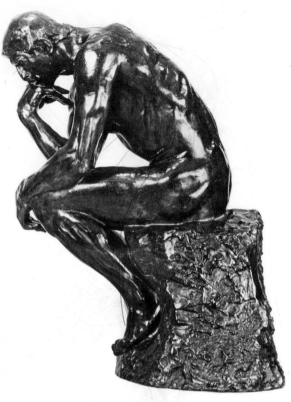

10 View of left profile.

11 Front view of left profile.

which *The Thinker* sits is only partly natural in its form. The top has been cut flat to serve as a seat and the front shaped to accommodate the contours of the legs and feet. From the statue's right side, the curve of the rock responds to that of the figure's calves, and both rhyme with the big arch of the back (fig. 5). This same view also shows that by reversing the curve of the back in the stone's profile, Rodin accentuated the springiness of the body. *The Thinker*'s durability as art depends in no small measure upon the constantly surprising changes in relationships discovered in its various profiles.

Rodin was obsessed with the ways the artist could seem to transform inert materials into life.[9] If we knew nothing about *The Thinker*'s history, the entire sculpture could suggest the theme of mind over matter. From what we do know, the relationship of the figure to the stone is relevant to who *The Thinker* was when the work was conceived. The provocative relationship of the man and the rock also invokes the dictum of Cézanne, who, a year older than Rodin, shared the sculptor's passion for absorbing himself completely in the motif "Nature thinks itself in me."

The Early History of "The Thinker"

In 1880, *The Thinker* came into being in its original twenty-seven-inch size as one of the first sculptures Rodin modeled for *The Gates of Hell*. It was neither the first nor the last seated male figure he modeled. Art students and decorative sculptors from 1850 to 1870 were trained and expected to give heroic proportions to the figure used in architectural sculpture. Rodin admired most the art of Jean Goujon and Pierre Puget. As a student he sat in the Luxembourg gardens dreaming of Goujon's colossal figures, some of which he could see on one of the facades of the Louvre (fig. 12). One of these figures, Euclid with his calipers, may have conditioned Rodin's later thought about *The Thinker*.

Rodin first indicated his ideas for the seated man in notations on architectural drawings for the portal in 1880, but its ancestry goes back at least to 1873 or 1874, when he was working in Brussels. After the defeat of the Franco-

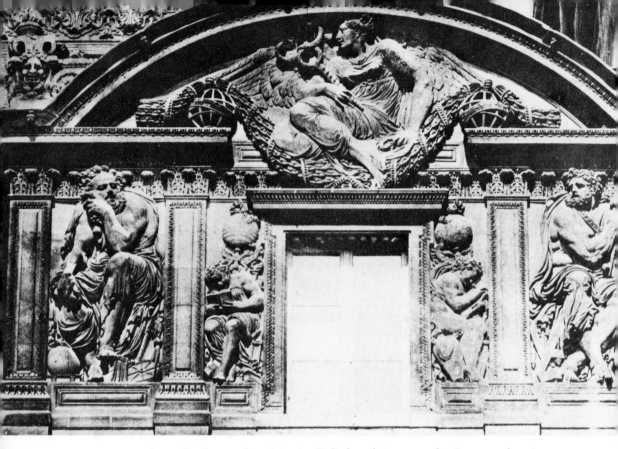

12 Jean Goujon and assistants, Relief sculpture on the Louvre showing
Mercury at the top, Archimedes at the left, Euclid at the right. Sixteenth
century, pavilion of Henry II.

Prussian war of 1870 and the Commune of 1871, there was no work for him
in Paris. For the garden of the Palais des Academies he designed a sculptural
still life of assembled objects symbolizing the various arts, the largest of which
was a stone copy of the famous *Belvedere Torso* that over the centuries had

come to represent Sculpture (figs. 13 and 14). Even though it was damaged before the Renaissance, this beautiful ancient fragment had never been buried and survived from antiquity without restoration. From the time of Michelangelo artists had copied its form, and Rodin had undoubtedly become aware of this sculpture as an art student in Paris. For the Brussels *Trophy of the Arts* Rodin probably acquired a plaster cast from one of the city's art schools—possibly the Academie des Beaux-Arts—that had study collections consisting of plaster reproductions of ancient sculptures and gave it to a carver for copying in stone. Even though Rodin may never have modeled an exact copy of the torso, he thus had a known and specific occasion to study it thoroughly, and as others have pointed out, the pose of the upper thighs and torso of *The Thinker* is unthinkable without *The Belvedere Torso*.[10]

Although we have no statements by Rodin on the ancient fragment, we can assume that he was moved by the heroic physique, the power of the modeling, the firm fullness and sensuous thickness of its form, and the sense of action imparted by the tensed muscles in a seated pose. For the artist who was to raise the partial figure to the height of a complete and serious work of art by 1900, this late Roman Republic ruin was an unforgettable lesson in the forceful expressiveness of the body without head and arms. As pointed out earlier, Rodin did not customarily build his figures from the ground up by thinking of the response of the feet and legs to gravity as the basis for his sculpture. Just a few years later in such full figures as *St. John the Baptist* and its derivative, *The Walking Man*, Rodin was to make the torso the pivotal core of the work, its artistic center of gravity, around which the volumes of the limbs were disposed.[11] The positioning of the pelvis and the axis from the genital area through the navel and sternum gave him a flexible, expressive nucleus for his bodies. For this Rodin may have been indebted to Apollonios, son of Nestor, the Athenian whose sculpture he would have seen in the Belvedere garden of the Vatican in 1875.

In the reserves of the Musée Rodin at Meudon is a small undated terracotta study of a seated or crouching male torso, an ancestral core of *The Thinker* (figs. 15 and 16). One can imagine Rodin holding the material in his hands and quickly thumbing and fingering the clay into bodily form. The angle at

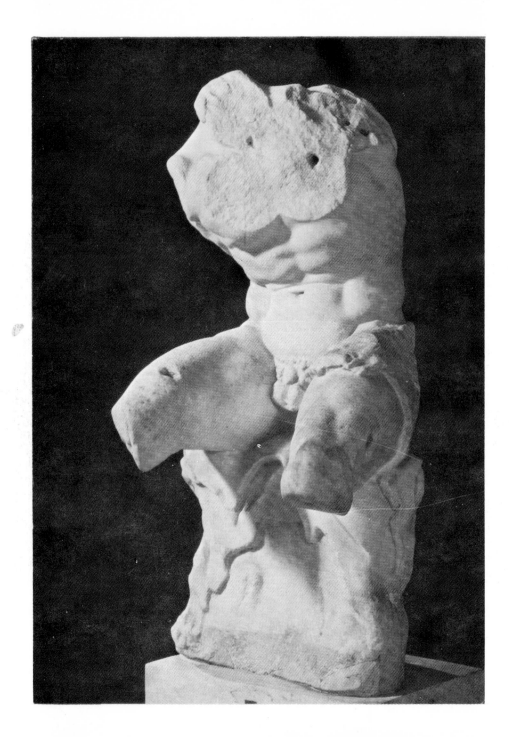

14　Rodin, *Trophy of the Arts*, 1874, Palais des Academies, Brussels.

13　Apollonios, *The Belvedere Torso*, The Vatican.

15 Rodin, Study of a seated or crouching male torso, terra-cotta, date unknown, Musée Rodin, Meudon. Rear view.

16 Study of a seated or crouching male torso. Front view.

which the *Belvedere Torso* bends has been reversed, perhaps a sculptor's tact in not calling attention to his source. Rodin raised the thigh on the same side as the bent shoulder, as did Apollonios. The étude shows Rodin's attempt to work out for himself not muscular stress but the broad formation and arrangement of bodily planes in a compact pivoting pose. This study may have been done even before he examined the Roman fragment and may have been inspired by another source. Rodin may have been making his own variation on the crouching flayed figure created in Florence in the sixteenth century and used thereafter in art schools for anatomical study. By its preservation, Rodin obviously prized his sculptural nugget that linked to the past his learning of how to become a dramatist of the body.

In 1875, Rodin traveled to Italy to study the work of Michelangelo firsthand.[12] Rodin realized that while making allegorical figures for a monument to a former mayor of Antwerp named Loos, he had unconsciously created sculptures that were Michelangelesque.[13] He wanted to fathom Michelangelo's "secrets" in the originals, but he also sought to discover the differences between his work and Michelangelo's. Although Rodin's figures on the Loos monument were destroyed, old photographs show us what they looked like (figs. 17 and 18). They were carved by someone else—not to Rodin's satisfaction. The personifications of Industry and the Merchant Marine are seated figures who, pivoting from the waist and neck, look over their shoulders. More decorative than dramatic, they lack the rugged compactness, complex architecture, and internal motivation of Michelangelo's sculptures. The Loos project allowed Rodin to experience working on a large scale. It seems also to have taught him what *not* to do compositionally and to have encouraged him to visit Italy in 1875 to see firsthand the work of an artist who had begun to haunt his thoughts during the Loos project.

17 Rodin, *Industry*, from the now destroyed monument to J. F. Loos, 1874–76 Antwerp. (The head survives in a private collection.)

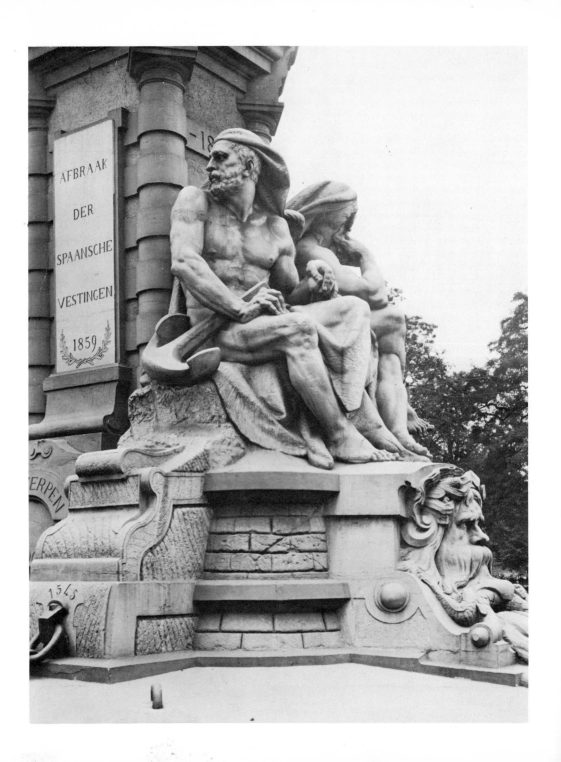

From his few letters and in drawings made before the Medici tombs and the statue of Moses, we are told little of what Rodin learned about Michelangelo during his visit to Florence and Rome. More tangible evidence appears in later statements, drawings, and sculpture.[14] For example, sometime between 1875 and 1878, while working for the decorative sculptor Carrier-Belleuse, Rodin modeled the figures for *The Vase of the Titans*, which bore his employer's name, as was customary in the nineteenth century[15] (fig. 19). The poses of these muscular seated figures are much more varied, energetic, and fluid than the Loos personifications. Rodin was presumably inspired by his study of Michelangelo's nudes in the Sistine Chapel. In conjugating the expressive poses of the *atlantes*, as such decorative figures were called, Rodin sometimes lowered the head and crossed an arm over to the opposite leg. He also placed pairs of flexible joints at greater variance with horizontal alignment. In retrospect, it appears as if Rodin sculpted the figures going through Michelangelesque limbering exercises, upon which he also drew in making the dynamic, compact form of *The Thinker*.

In his reflections on Michelangelo after 1875, Rodin also let his live models assume Michelangelesque poses. This practice led him to believe that the great Renaissance sculptor had found his structural devices in nature.[16] While this is only an assumption, after *The Thinker* Rodin did turn away from poses associated with art history and he concentrated on ones more natural to a live subject.

Sometime after returning to Belgium from Italy, Rodin continued work on his *Age of Bronze*, and he undertook a new work on a subject from Dante's *Inferno*, Count Ugolino (figs. 20 and 21). (Once a heroic admiral, Ugolino was imprisoned in a tower with his children and grandchildren and allowed to starve as punishment for betraying his city of Pisa.) We do not know whether Rodin ever made a full figure of Ugolino. What exists is a life-size sculpture of a seated, heavily built male nude lacking a head and extremities. This was

18 Rodin, *The Sailor*, from the monument to J. F. Loos. (The head survives in a private collection.)

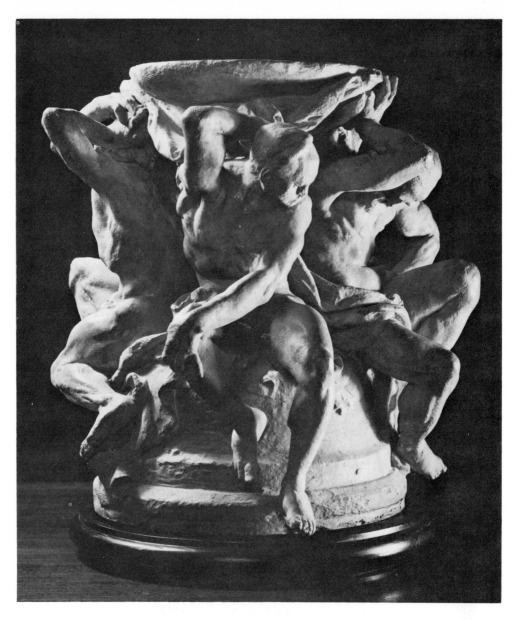

19 Rodin, *The Vase of the Titans*, terra-cotta, 1878–1880, location unknown.

20 Rodin, *Seated Ugolino* (side view), plaster, 1876–77, Musée Rodin.

its condition in 1877, when Rodin wrote from Paris asking his mistress, Rose Beuret, to ship it to him.[17]

Truman Bartlett, a young sculptor who saw *The Ugolino* in Rodin's studio after the artist's return to Paris, wrote, "It looked a bit like Michelangelo; it was so large, lifelike, and ample in the character of its planes and modeling" (p. 41). The young artist and other studio visitors were probably not aware of Rodin's contact with *The Belvedere Torso*. Although Rodin had an older and riper model than the athlete presumably used by Apollonios, *Ugolino*'s pose, especially the downward rotation of the right shoulder and the position of the thighs, seems as close to the work of Apollonios as to that of Michelangelo, who had himself assimilated the form of this torso in, for example, the figure of *Day* for the *Tomb of Giuliano de' Medici*. Rodin's own drawing of *Day*, made some time after his return from Italy in 1875, reminds us of how he could have perceived the way Michelangelo absorbed the influence of Apollonios (figs. 22–24). In turn, this revelation could have challenged him to make his own paraphrase of *The Belvedere Torso*, as well as Michelangelo's *Day*.

The *Ugolino* also suggests that Rodin was dissatisfied with the figures on the Loos monument and sought to rework them with a more vigorous upper body torsion learned from Michelangelo's sculpture in the Medici Chapel. A photo of *Ugolino*'s right side taken under Rodin's direction shows that, despite the differences in the positioning of the arms, it closely resembles *The Thinker* from the knees upward. There is even evidence that in 1880 *The Ugolino* sculpture may have been destined to be *The Thinker* and was to have been placed in front of *The Gates of Hell*. The ink inscription written in Rodin's hand over some architectural notations at the top of the photograph says, "ira au pied de la porte" (to go at the foot of the door).

The Thinker is often said to have been inspired by Carpeaux's *Ugolino and His Sons*, chiefly because of the father's seated position and the placement of his right arm (fig. 25). Rodin is known to have admired this great French sculptor of the Second Empire. Carpeaux's work had been made in 1860, and

21 *Seated Ugolino* (rear view).

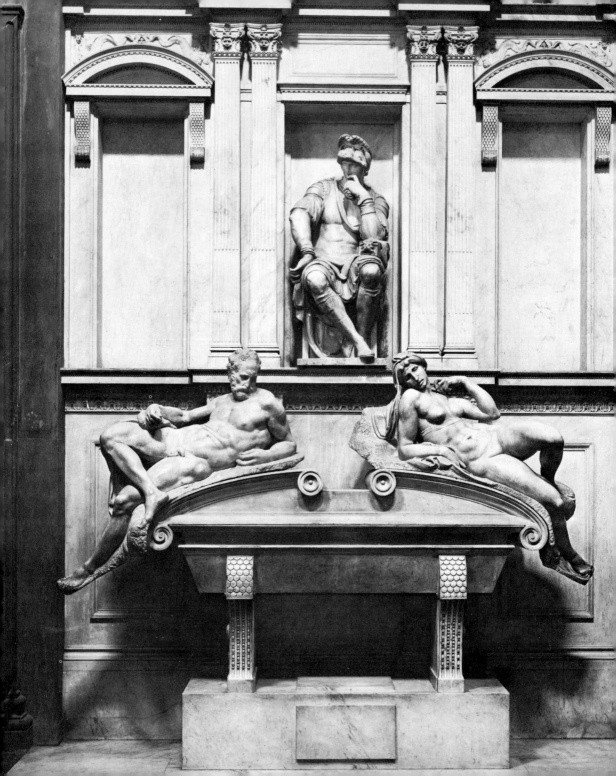

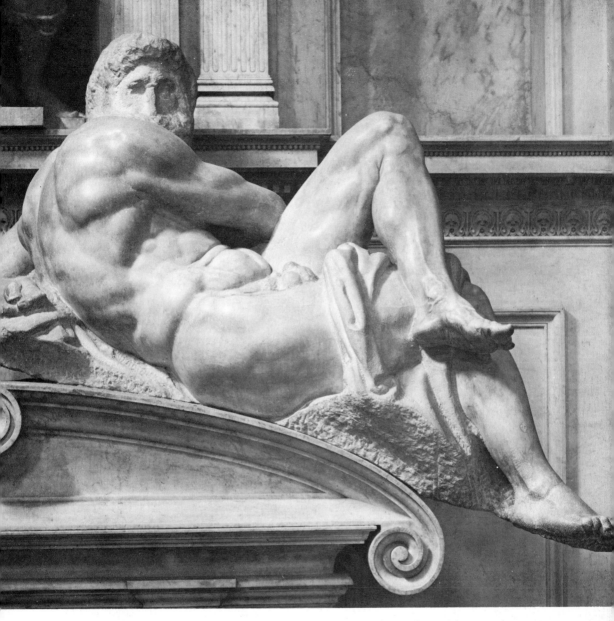

23 Michelangelo, *Tomb of Giuliano de' Medici,* with the reclining figure of
Day, 1524–34, Medici Chapel, Florence.

22 Michelangelo, *Tomb of Lorenzo de' Medici* with the reclining figures of
Dusk and *Dawn,* 1524–34, Medici Chapel, Florence.

24 Rodin, drawing after Michelangelo's *Day*, date
unknown, Musée Rodin.

Rodin may have seen bronze reproductions in Paris. The problem with as-
cribing *The Thinker's* distinctive arm movement to Carpeaux or any other
nineteenth-century source is that it supposes Rodin had never had any ex-
perience with *The Belvedere Torso* and that he had forgotten what he had studied
firsthand in Italy in 1875, all of which is unlikely. Rodin made the large *Ugolino*
shortly after having directly confronted Michelangelo's art—not to test his
relationship to a work that was rather unusual for Carpeaux. Other than the
seated, arm-crossed pose, Carpeaux's *Ugolino* and *The Thinker* have little in

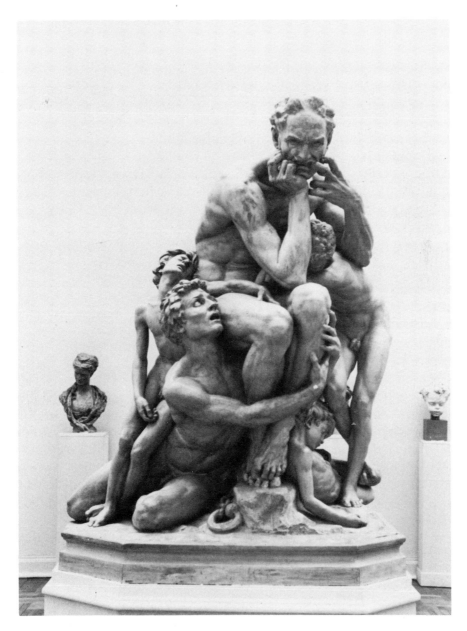

25 Carpeaux, *Ugolino et ses enfants*, original plaster, 1857–61, Valenciennes, Musée.

common. The similar positioning of the right elbows is more easily explained
by the two sculptures' common source in Michelangelo. Before 1870 Carpeaux
may have contributed to Rodin's interest in Michelangelo, which in turn was
manifested in the Loos Monument. Rodin owned a bronze cast of a sketch
for Carpeaux's group, which shows that he admired it, but he did not acquire
the cast until 1911.[18]

Either shortly after his return to Brussels in 1875 or, more probably, in
1880, Rodin made a small but highly finished seated figure that is crucial to
his reflections on Michelangelo and to the origins of *The Thinker*[19] (fig. 26).
This figure diminishes the likelihood of Carpeaux's influence. In the small
nude Rodin worked out the structural principles of reorienting one of Mi-
chelangelo's reclining *Times of Day* into an upright, seated position.[20] His male
wax figure is sitting on a rock which is shaped somewhat like *The Thinker*'s,
especially with respect to the position of the left leg and foot. Like Michel-
angelo's *Dawn*, he swivels from the waist to his left, posting his right elbow
to his left thigh. The genitals have been modeled more fully than in the final
Thinker and, while discreetly covered, are not a feature Rodin would have
contemplated for the Loos project. *Dawn*'s right leg is extended downward
and bent at the knee. The man's right knee is dropped toward the ground,
requiring that the thigh be lengthened in proportion to the whole leg, as in
The Thinker. Again, Rodin followed Michelangelo in taking artistic liberties
with anatomical proportions. The man's head is up and turned to his left,
like that of *Giuliano de' Medici*, but he does not appear to be looking at some-
thing. The pose of the right arm evokes the idea of thought. His left hand
grasps the stone beneath him. In a gesture almost exactly like that of the left
hand of Michelangelo's *Dawn*, as well as that of *Industry* in the Loos monu-
ment, the forefinger of his right hand rests against his neck. Given the subjects
of the male figures for the Loos Monument, Industry and the Merchant Ma-
rine, this small sculpture does not seem to be a study for either one.[21] In fact,

26 Rodin, *Seated male nude*, wax, 1875–76 or 1880, Nelson-Atkins
Museum of Art.

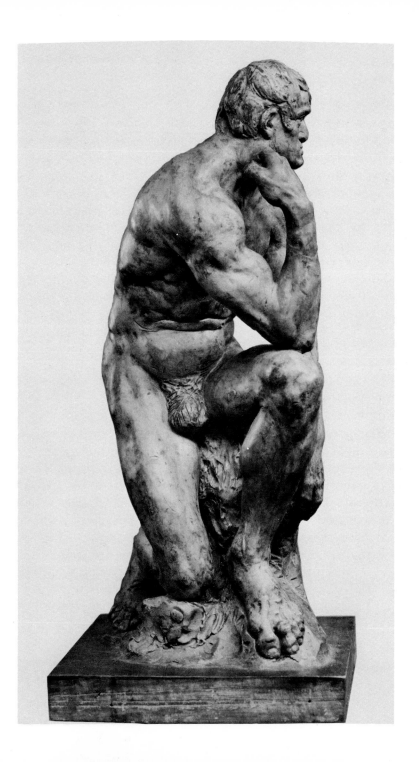

the man's gestures could be read as signifying his identity as a sculptor who works from the self and shapes matter with his hands. The absence of such customary attributes as an industrial tool are more appropriate to a study for *The Thinker* than to a personification of the Belgian fleet or a representation of factory workers.

It has been argued that the style and anatomical exactitude of the small figure is too close to that of the Loos Monument and too detailed for dating in 1880, but this view overlooks the simultaneity of modes in Rodin's art. *The Kiss*, for example, made after 1880 for *The Gates of Hell*, was detailed and finished by Salon standards.[22] The face of the seated figure and his body (with the curled toes) could have served for *The Thinker*. Small differences between the two could be accounted for on the grounds that Rodin was known to make cosmetic or slight anatomical alterations from the model, especially in such areas as the face, to win a new identity for his final sculpture.

The 14½-inch wax study is almost exactly half the height of the first 27-inch version of *The Thinker*, whose head is bowed rather than upright. It was Rodin's practice at times to make a first study half the size of a proposed work and to enlarge it, but not always without change. Finally, no studies by Rodin have survived for the Loos Monument, a project he was not proud of. Whether made in 1875–76 or 1880, this small sculpture is crucial to the development of *The Thinker*. The differences between them remind us of the many decisions Rodin felt compelled to make in the arrangements of the limbs when moving to the final size and emphasize how radically each choice can alter the subject's meaning. (The changes in *The Burghers of Calais* through their successive models constitute a case in point.) Pondering this small wax, whether it had been made a few years or a few days before *The Thinker*, Rodin decided to compact, restructure, and reorient the entire composition to give more authority and importance to the frontal view, which would be the one most visible in *The Gates*. Given this background, it seems clear that *The Thinker* was part of Rodin's deeply serious attempt to personalize, naturalize, or even democratize Michelangelo's aristocratic art—rather than simply to paraphrase a pose or gesture found in a single work of another nineteenth-century artist.[23]

"The Thinker" and "The Gates of Hell"

In 1880, for a proposed new museum of decorative arts, Rodin was commissioned by the French government to make a bronze portal. The subject of its reliefs was to be drawn from Dante's *Divine Comedy*. Rodin's preliminary drawings for the project show that he first thought of a Renaissance format having panels of shallow bas-reliefs that would presumably contain illustrated episodes from Dante. A few drawings that could be interpreted as relating to these panels, as well as notations in the architectural drawings, show the frequent appearance of a seated, unclothed male figure.[24] One historian has seen *The Thinker*'s ancestry in these sketches.[25]

The first drawn indications of *The Thinker* positioned near the top of the portal are on the same sheet and are so synoptic that they evoke only the overall curvature of his bent pose, although one also shows the crossing gesture of the right arm (fig. 27). In the final architectural study, Rodin included a modeled sketch of a figure which is recognizably an ancestor of *The Thinker*, but with some interesting differences (figs. 28 and 29). The knees are together, and the right hand with the forefinger extended upward rests alongside the head. The relation of head to hand was clearly one that Rodin pondered a long time. In the reserves of the Rodin Museum at Meudon outside of Paris, there is a small terra-cotta sketch of the left side of a seated man whose left elbow is propped on his left knee (fig. 30). The chin rests in the palm and the fingers are pulled back in a fist. This is undoubtedly a natural pose for someone seated and in thought, but after modeling it, and not for the first time, Rodin found compelling reasons to return to a gesture with art as its source. (This study may, however, have been for a later work, *The Sculptor and His Muse*.) There is also a drawing of a nude male seated upon the headless body of another male (fig. 31). This violent motif may have its source in Dante. Rodin has edited the drawing to indicate that he wants the supporting arm to rest on the opposite thigh. Thus, it appears the decisions involving the placement of both hands and knees and the lowering of the

27 Rodin, Sheet of drawings for *The Gates of Hell*, 1880, from a note-book in the Musée Rodin.

28 Rodin, Third and last architectural model for *The Gates of Hell*, plaster-painted terra-cotta, 1880.

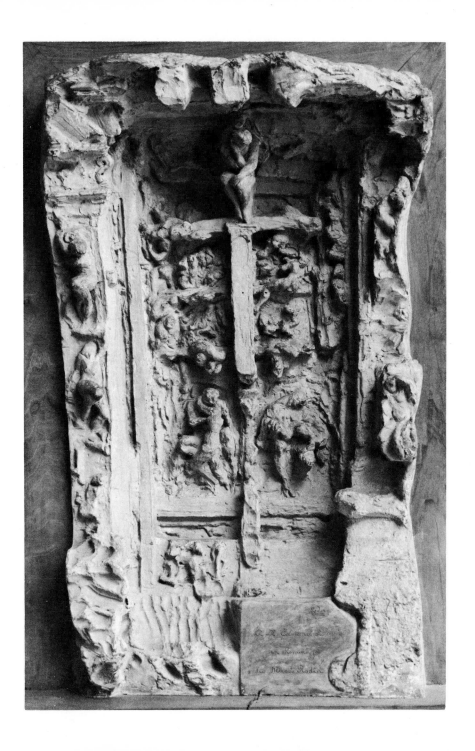

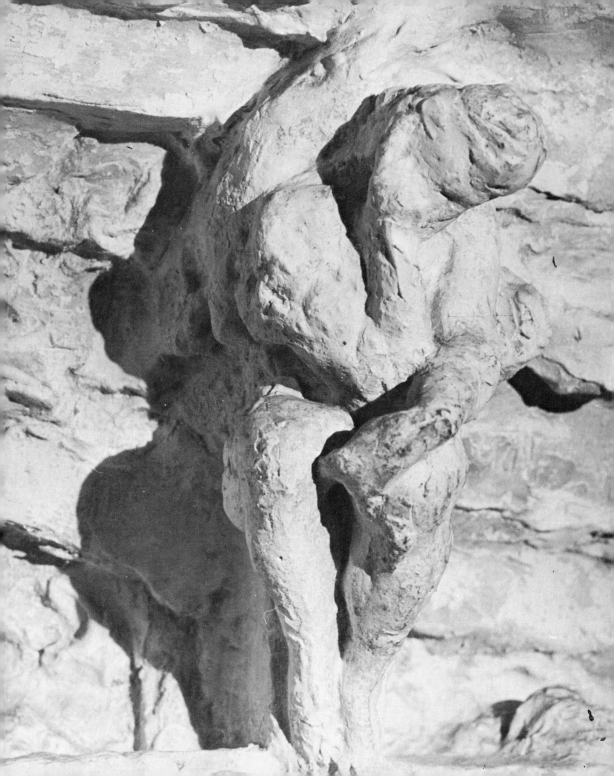

head did not come about until Rodin actually made *The Thinker*, probably late in 1880.

There is no statement by Rodin from 1880 or for many years thereafter on how *The Thinker* came about and what his intentions were for it in *The Gates*. In 1904, however, when the enlarged version of the sculpture was first shown in public, he wrote a letter to the critic Marcel Adam that was printed in the July 7 edition of *Gil Blas*:

> *The Thinker* has a story. In the days long gone by, I conceived the idea of *The Gates of Hell*. Before the door, seated on a rock, Dante, thinking of the plan of his poem. Behind him, Ugolino, Francesca, Paolo, all the characters of the Divine Comedy. This project was not realized. Thin, ascetic, Dante in his straight robe separated from the whole would have been without meaning. Guided by my first inspiration I conceived another thinker, a naked man, seated upon a rock, his feet drawn under him, his fist against his teeth, he dreams. The fertile thought slowly elaborates itself within his brain. He is no longer dreamer, he is creator.

Rocks on the Thinker IMP

There is no evidence that Rodin ever attempted a clay or drawn sketch of his thin, ascetic Dante in a robe. By no stretch of the imagination could *The Thinker* that was first made for *The Gates* be considered faithful to the historical likenesses of the great poet that were available to Rodin and that had caused him to refer to the poet's straight robe. The very year Rodin began work on the great portal, Jean-Paul Aubé's statue of Dante was installed before the College de France in Paris[26] (fig. 32). In 1914, Rodin found someone who resembled images of Dante and used him as a model for a portrait of the author (fig. 33). In 1880, Rodin could not have even conceived of a sculpture showing Dante in the nude! For all his audacity, Rodin retained a sense of decorum that in certain respects matched that of his more conservative colleagues—specifically, that historical figures shown in public should be clothed.

29 Detail of *The Thinker* in the third architectural study for *The Gates of Hell*.

30 Rodin, Study for *The Thinker*, terra-cotta, 1880, or *The Sculptor and His Muse*, 1890 (?) Musée Rodin.

31 Rodin, *Man Seated on a Headless Corpse*, drawing, 1880 (?)
Musée Rodin.

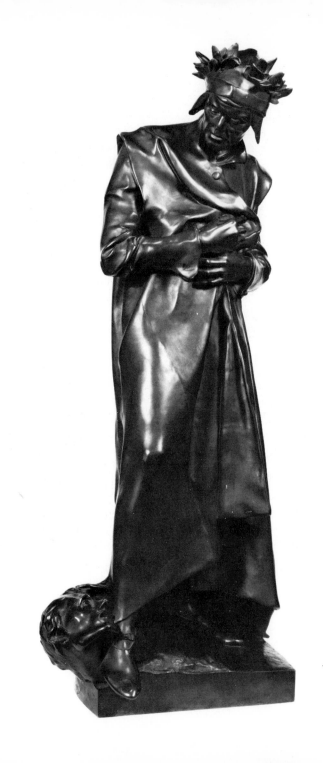

33 Rodin, *Head of Dante*, plaster, 1914, Musée Rodin.

32 Jean Paul Aubé, *Dante*, bronze, 1879, Stanford University Art Museum, on loan from the B. G. Cantor Collections.

Yet many visitors to Rodin's studio read this sculpture in the portal as being Dante, and they were not contradicted by Rodin. The reason for his silence may be found in his letter to Marcel Adam. The second "thinker" conceived by Rodin was a *creator*, and this designation included but did not restrict to Dante who *The Thinker* was to signify.

[handwritten margin note: More open, universal / sawin]

Rodin had photographs taken while *The Thinker* was still in clay, probably so he could study this crucial work in a detached way.[27] These photographs are refreshing views taken before this sculpture became a visual cliché. Here and there, notably in the neck and waist area, remain bits of clay from editing that will be removed, and the armature still protrudes from the rock (figs. 34 and 35).

The view that Rodin had the photographer take may tell us which he believed delivered the greatest impact. Not surprisingly, it shows the fullest view of the face and the dramatic intersecting axes made by the limbs. The design is a simple, bold, full-length crisscrossing. Each arm seems to unite with the opposite leg. The head, right arm, and left leg appear continuous— brain, hand, and gripping foot act as one. The cubified silhouette stabilizes the strong diagonals of the feet, shoulders, and knees, thereby giving the whole a powerful projection.

One of the photographs has been edited by Rodin, who was unhappy either with the print or with his treatment of the figure's hair (fig. 35). With a pencil he darkened *The Thinker*'s right brow, suggesting that he wanted more shadow. On the crown of the head he drew what looks like an Indian feather headdress, not as a prank, but perhaps to see what a different treatment of the hair would achieve. Other photographs show the wooden box frame for the first large version of *The Gates*. Before it Rodin had erected a high platform on which *The Thinker* was placed so that he could study its effect from below (fig. 36). Up to this point, Rodin had not made provision in the design of the box frame for placing the figure in the center of the upper section. Such provision was also lacking in the third architectural model, and

34 Rodin, *The Thinker*, clay, 1880-81 (Photo in Musée Rodin archives).

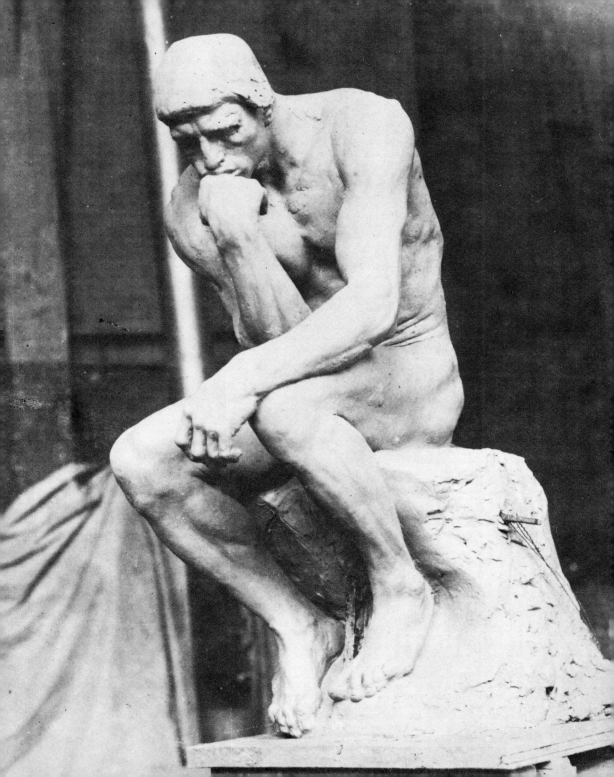

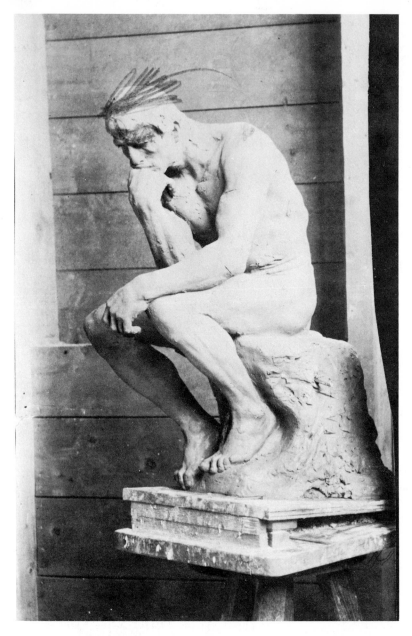

35 Photo of *The Thinker* in clay with Rodin's pencil notations, (Musée Rodin archives). The sculpture is shown before the original wooden box frame of *The Gates of Hell*.

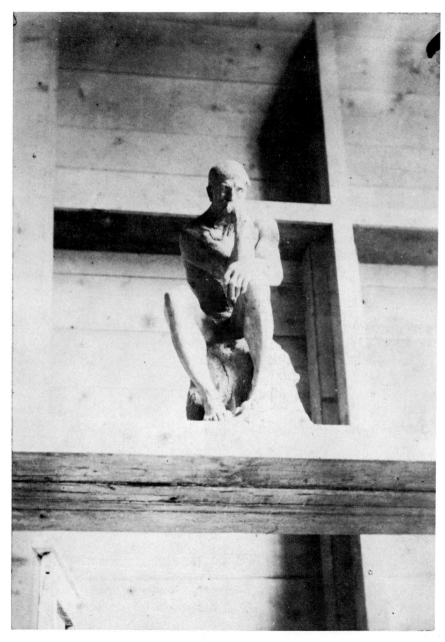

36 *The Thinker* in clay on a scaffolding before the wooden box frame of
The Gates of Hell, 1880–81 (photo in the Musée Rodin archives).

figure 29 shows that the small sketch of *The Thinker* was attached to the upper vertical divider of the model that had first been conceived without him. At the time of the photographs, what was to become the tympanum was separated into two parts by a vertical divider that rose to the curved ceiling at the top of the portal. Rodin's statement to Marcel Adam suggests that he had originally thought of putting *The Thinker* in front of *The Gates*.

Rodin's technique of modeling successive profiles of his figures from all points of view, which he developed while working on *The Age of Bronze*, allowed him the freedom of raising *The Thinker* far above eye level, knowing that its profiles and design would hold. The wedge-shaped platform atop the modeling stand, visible in the photographs taken slightly below eye level, was meant primarily to allow more light on the upper part of the bowed figure, but it may also have helped Rodin gauge its effect from slightly below. Photographs helped reassure him on that score. The photographs are not all taken directly from the front, because Rodin designed his sculptures so that looking at them off center would show the thickness in depth that he believed was vital to good sculpture.

Why did Rodin abandon the conception of showing Dante either before or near the top of *The Gates of Hell*? Elsewhere I have discussed at length how at the earliest stages of creating the portal on its large scale, Rodin moved from literal illustration of episodes from *The Inferno* to a very personal and modern view of hell.[28] Rodin in effect departed from the warrant of his official commission without authorization. This was a considerable professional gamble for a middle-aged and relatively unknown artist with influential enemies, a man who until 1882 was still receiving an hourly wage for decorative work in the government's ceramics factory in order to support his family. Rodin's selection for the commission by the Under Secretary of State for Fine Arts, Edmond Turquet, constituted in itself a serious political risk by an appointed government official. These circumstances may also explain why he did not contradict visitors who read *The Thinker* as Dante.

Critical Reaction to "The Thinker" before 1889

The first mention of *The Thinker* in print is found in an unsigned article entitled "Current Art" published in 1883 in the English *Magazine of Art*: "Just now the artist is engaged upon a pair of colossal bronze doors for the Palais des Arts Decoratifs. The subject is the 'Divina Commedia,' and the work will be in relief. Some parts of it exist already in the round: a superhuman 'Dante' . . ." Rodin's practice of first making most if not all of his figures for the portal in the round meant that he did not immediately mount them in *The Gates* during the first years of work. This may explain why the first description of *The Thinker* as Dante in the context of the portal did not come into print until 1885. On February 18th of that year, Octave Mirbeau published the first important description of the doors in *La France*: "Above the capitals of the door, in a panel with a slightly curved vault, there figures Dante, who very much stands out and who detaches himself completely from the background that is covered with reliefs that represent the arrival in hell."

In *The Inferno*, the judge Minos greets the new arrivals, and by the number of times his serpent's tail circles his body he determines into which circle of hell a sinner is consigned. None of Rodin's contemporary commentators make this association. The sculptor made a drawing, which he published in 1898, of Minos in judgment, shown as an upright, seated man amidst an agitated crowd.[29] When Rodin located *The Thinker* in the tympanum before a crowd of figures, the analogy could not have been lost upon him.

On January 16, 1886, there appeared in the *Supplement du Figaro* an article by Félicien Champsaur titled "He Who Returns From Hell: Auguste Rodin," which contained the second detailed description of the portal. "Standing out on a bas-relief, the arrival in hell, is a thoughtful Dante Alighieri; chest forward, elbow on a leg, chin resting on his hand, his inspired gaze seems to plunge to the bottom of the abyss where are mixed the grinding of teeth and kisses." Champsaur's article was clearly influenced by Mirbeau's. One wonders whether these writers had actually discussed with Rodin who *The Thinker* was or if they only made assumptions from the literary source cited in the commission.

The one writer who obviously talked at length with Rodin was the American sculptor Truman H. Bartlett, who wrote a series of articles on the sculptor which appeared in the *American Architect and Building News* in 1889. These articles remain our best source of information on Rodin and his art to that date. Although Bartlett's notes, written in December of 1887, are useful as a supplement to the articles, they do not always answer questions raised by the texts.[30] For example, in one of his articles devoted to *The Gates*, Bartlett wrote, "The salient subjects of the door are the episodes of Paolo and Francesca di Rimini and Ugolino, but the composition includes the three phantoms and Dante." In his notes, Bartlett did not mention Dante in this connection. Bartlett's article later continues:

> And the Dante, he that looks down upon hell. For an expression of a deep understanding of and a penetration into the very soul of him who walked through the abodes of the cursed and saw its endless grief, what could be more complete than this statue? This awful Thinker: seen from his left, he looks like a bird of prey contented with the vengeance he has meted out to the vile of the earth, a composition of mental and physical dominance, an effect of personality seemingly without rival in all the sculpture of the world. (p. 70)

This passage does not appear in the notes, nor are there relevant quotations from the artist. It is clearly Bartlett's own interpretation, possibly written some time after his sessions in Rodin's studio and perhaps not even when he was in France.

"The Thinker" and Baudelaire's "Les Fleurs du Mal"

In 1887 the collector Paul Gallimard commissioned Rodin to illustrate Baudelaire's *Les Fleurs du Mal*.[31] In Rodin's estimation he was given too little money and time to give the project his best effort. Nevertheless, he produced twenty-seven beautiful drawings, twenty-two of which were made directly on Gallimard's personal copy of the book. Perhaps to save time, but also because they shared the poet's thought, many of the drawings were made from sculp-

tures destined for *The Gates of Hell*. Some of his drawings are not literal illustrations but accompaniments for the text; in some cases Rodin was inspired by one or two lines from a poem.

Such was the case when he drew *The Thinker*, as if seated on a rock in a cave, in the margin of the poem "Les Bijoux" (fig. 37). The poem is about the attempted seduction of the poet by the temptress of his dreams who is naked except for her lover's favorite jewelry. She advances cunningly toward him "in order to trouble the repose of my soul, and to disturb it on its crystal rock, where calm and solitary it was seated." These lines inspired Rodin to select *The Thinker* to accompany the poem as the incarnation of the poet's soul struggling to maintain its untroubled detachment from all temptation or distraction. Within *The Gates*, the seated man has his back to the crowd of voluptuous women who gyrate behind and around him. (Baudelaire's temptress is also a work of art.) This context makes the selection all the more understandable. It was probably Rodin's meditations on Baudelaire's poem and the choice of *The Thinker* to represent the poet that influenced his title for the work when it was first publicly shown in 1888 in Copenhagen as *Le Poète*.

The First Paris Exhibition of "The Thinker"

In 1883 Rodin had begun to publish and then to exhibit drawings and sculptures related to *The Gates of Hell*. By showing his plasters for the portal, Rodin had the opportunity to further his reputation and sell bronzes cast from these exhibited works. On December 1, 1884, a Mr. C. A. Ionides wrote to Rodin from Brighton, "Our main house in the city informs us of the arrival of a large crate. Would it be your 'Penseur'?"[32] (Three years earlier Ionides had written Rodin telling him of the widths of the mantle over his fireplace and "another place," asking the sculptor which of the two he would prefer, implying they were for one of Rodin's sculptures.) Ionides' 1884 letter is the first recorded use of "The Thinker," a title he obviously got from Rodin.

In June 1889, in conjunction with a large showing of Monet's paintings, Rodin had an important exhibition of thirty-six sculptures, many of which were from *The Gates*, at the Gallerie Georges Petit in Paris. *The Burghers of*

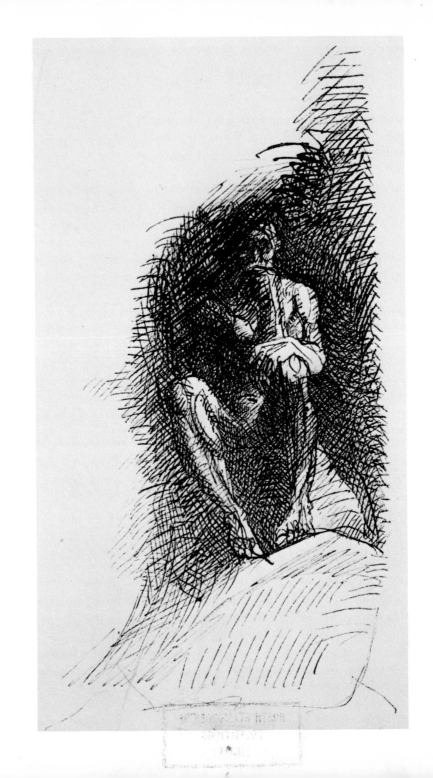

Calais drew the greatest critical and public attention, because it was being shown for the first time. He exhibited for the second time his seated figure, which he titled not *Dante* but *Le Penseur: Le Poète.* (There exists in the archives of the Musée Rodin Rodin's own handwritten list of titles from which those in the catalogue were taken, so that we know he supplied the names, rather than Georges Petit.) From this date contemporary commentators with few exceptions were less inclined to identify this sculpture in the portal as Dante.

Rodin's choice of the word *Penseur* (Thinker) could have derived simply from the pose or subject of his work. It is also possible that its selection may have been influenced by Victor Hugo's use of this word. In 1883, Rodin had occasion to spend considerable time with the great poet while doing his portrait. It was Rodin's practice to learn as much as possible about his subject in order to inform the evolving portrait with a sense of the subject's character. In addition to listening to Hugo, often at the writer's dinner table, Rodin would have read extensively in Hugo's writings. As M. Z. Shroder has pointed out in his excellent book *Icarus: The Image of the Artist in French Romanticism*, Hugo wanted to be the Poet of Humanity, and saw himself as

> the mage—poet, philosopher, priest, and politician. *Penseur* was the word Hugo often used; and, he explained, *penseur* is an active noun. The poet-mage, according to Hugo, pursued the universal mysteries as the poet pursued nature. He had first to anchor himself in human knowledge, then to plunge into the contemplation of the irrational and the mysterious. . . . The rule for mage is always to "go beyond." To understand man, he has to understand nature; to understand man and nature, he must contemplate infinity. This is, said Hugo, the "supreme contemplation." The means for the contemplation of infinity, of universal mystery, is intuition, "the immense internal eye." (pp. 88–89)

37 Rodin, Drawing for Baudelaire's poem "Les Bijoux" showing *The Thinker*, 1887.

As part of his personal war with academic and conservative official art, Rodin would have sympathized with the older man's drive to transform the arts from an aristocratic to a democratic language. In the 1850s, as Shroder points out, Hugo took the position that the masses were his muse, and he declared himself a hero of the people, offering encouragement to "the *ouvriers-poètes* (worker-poets) who flourished in this period" (p. 74). Because of his socialist views, Hugo arranged for his body to be transported on a poor man's hearse after his death.[33]

Almost as important as *Penseur* was Rodin's choice of the nomination *Le Poète*. He had drawn his inspiration for *The Gates* from at least two great poets, Dante and Baudelaire, and we can find among many other nineteenth-century writers sentiments that verbalize those the sculptor expressed in his portal.[34] By his choice of title, Rodin seems to credit his sources, as well as their role in society. This could be too narrow a view, however. Rodin believed in a great brotherhood of creators that cut across media and time, and it is not hard to understand how this idea came to him. Marcel Adam, a poet and a friend of Rodin, proclaimed on the occasion of the public installation of the large *Thinker*: "Every artist is a poet."[35] On many occasions Rodin was himself referred to as a poet. Camille Mauclair, in his 1905 book on the artist, wrote, "I consider Rodin a very great poet—not in the sense that he dislikes, but on the contrary, by giving the word 'poet' its deep etymological significance according to the Greek, that of 'making, creating, vivifying' " (p. 69). Although writing about an older generation than that of Rodin, Shroder explains the significance of the word "poète" in France during the first half of the nineteenth century, a meaning it may still have carried (at least to some) in 1880.

> The word poète was a Romantic term of approval and a password to acceptance in the cenacles and the studios, to be sure; but it carried a broader meaning than "he who writes verse." The poet, in the absolute sense in which the Romantics of 1830 understood the word, was the man of imagination, the creative genius—versifier, novelist, painter, sculptor, musician. In fact, the emphasis laid on imagination and on creative activity was so great that the poet—and, indeed, the artist, though the use of this word was somewhat more strict—did not even have to be concerned with art at all. (p. 9)

Unlike Hugo, Rodin never had any pretensions of nobility at any stage of his life, and his relationship to the masses was more consistently genuine and free of pity. Rodin's proposed monument to labor in the form of a *Tower of Labor*, which got only as far as the model stage in the mid-1890s, was a sincere expression of his respect for and identification with the manual laborer.[36] (He wanted to be buried in the crypt of the tower.) His own view of himself as an artist was not as an exalted person, but rather, as he put it in 1880, as an "artist-mason."[37] When Rodin created *The Sculptor and His Muse*, he gave to the artist a mature worker's muscular body and a pose similar to *The Thinker*[38] (fig. 38). The sculptor's face is the second, more aged version of *The Man With a Broken Nose*, the model for which had been a poor local laborer who gladly sat for Rodin. The figure's pose, with the right elbow supported on the right knee and the hand over the lower portion of the face, reverses that of the terra-cotta study (fig. 30) that could have served for either *The Thinker*, *The Sculptor*, or both. The muse binds herself to the artist with her hair, and her left hand grasps her right foot ("mettre le pied dans la main" was a French idiom for orgasm), while her right hand touches the man's penis. Following Balzac, Rodin no doubt believed that artistic creativity was also a matter of sexual potency. No other nineteenth-century sculptor was as sexually frank about the intimate relationship of the artist and his muse. Within *The Gates*, as already pointed out, Rodin's *Thinker* maintains physical detachment from the women about him, but his thoughts are filled with the passion that animates the damned around him.

Given the physical character and attitude of the sculpture and its content within *The Gates of Hell*, it is not unreasonable to consider *The Thinker* Rodin's spiritual self-portrait as a worker-poet. It was, in fact, the figure's universally recognized plebian character that caused Rodin so much difficulty when *The Thinker* was separated from *The Gates*, enlarged, and placed in public in 1906. Between that time and 1889, however, the critics who saw the sculpture in relation to *The Gates* read it more sympathetically and, not surprisingly, compared it with Michelangelo's sculpture of Lorenzo de' Medici, which in Rodin's day the French referred to as the "Pensieroso."

Critical Reaction to "The Thinker," 1889–1900

One of the first reviews of the 1889 exhibition is found in an article entitled "Paris Vivant" by Fernand Bourgeat, published June 20 in *Le Siècle*:

> *Le Penseur*, or *Le Poète*, is a large seated figure that those who see it for the first time will compare with the Pensieroso of the Medici tomb; but the visitor would do well to add that if there is a resemblance, it is not the shadow of an imitation: the "thinker" of Rodin is a "poet," an observer, a dreamer, and the shadow that floats across his brow does not come from the visor of a helmet. This statue is not destined for the corner of the tomb of a [General] Lamoricière [see fig. 53] or whoever; it will dominate the bronze door where the Divine Comedy unfolds its immortal episodes.[39]

On June 26, M. d'Auray wrote in his "Chronique," published in *Le Courrier du Soir*, that the works in the Petit Gallery constituted only a small fraction of Rodin's sculpture for *The Gates*, which should be seen in the artist's studio. He compared the plasters scattered about on the floor there to a battlefield covered with tortured bodies.

> Above, at the summit, as if frightened himself by his work, the artist, the poet, the creator is crouching, head in hands, pressing his brain to the limit; all of his being is gathered in an attitude of meditation and of dreaming. Rodin names this figure "The Thinker," [but] this one does not have the majestic and calm indifference of that one by Buonarroti; he is not leaning in repose but, overcome, is suffering, martyred by his own vision, by his intimate thought.

Rodin attracted the attention and friendship of many poets and writers.

38 Rodin, *The Sculptor and His Muse*, bronze, 1890, The Fine Arts Museums of San Francisco. Gift of Miss Alma deBretteville Spreckels.

One of the most gifted poets at that time was the Belgian Georges Rodenbach, who wrote about *The Thinker* in *The Gates* on June 28, 1889 in a Brussels newspaper.[40] "It is a picture of human passions looked at by the great figure that is at the summit and who represents not Dante, but the eternal poet, thoughtful and nude, in contemplation before that which Baudelaire called 'the boring spectacle of immortal sin.' " The English writer Arthur Symons also had occasion to visit Rodin's studios, and in his 1892 diary he described the plaster cast of *The Gates*: "On the frieze, around 'Le Penseur,' there is a Dance of Death.... They clasp and writhe in agony and delight, moving simultaneously, swarming around 'Le Penseur,' who sits, immobile, contemplating hell" (p. 126).

At least three writers referred to *The Thinker* as Dante in 1898 and 1899. Edouard Rod saw the figure as "Dante, seated in an attitude that recalls a little of that of the Pensieroso" (p. 426). Henri Frantz saw "Dante, absorbed and thoughtful, his eyes fixed on the infinite, with the lofty expression assigned to him by tradition into which the sculptor has infused increased serenity... released from human sorrow, and he contemplates... that swarming creation that surges around him" (p. 275). H. S. Brownell saw in the face of this Dante "the rapt and sinister countenance of the beholder of visions, the dreamer of dreams."

We can compare these interpretations to those of writers much closer to Rodin's thought and art. In 1898, Camille Mauclair, who had already published important articles on Rodin, wrote at length about *The Gates*, citing astutely *The Thinker*'s thematic and formal centrality and making him into a humanist:

> The sculptural role of the Three Shades is entirely subordinate to the statue
> of the seated man, who, before the tympanum filled with frightened scenes,
> is posed on the topmost bay of the door, like the general thought of the work.
> It is toward him that all the decorative unity converges, that of the summit
> like that of the panels and the vertical side reliefs. All the sculptural radiance
> ends in this ideal center. This prophetic statue can carry in itself the attributes
> of the author of The Divine Comedy, but it is still more completely the rep-
> resentation of *Penseur*. Freed of clothing that would have made it slave to a
> fixed time, it is nothing more, in its severe nudity, than the image of the

reflection of man on things human. It is the perpetual dreamer who perceives the future in the facts of the past, without abstracting himself from the noisy life around him and in which he participates, seeking to understand all the complaints.[41]

The author of the first book on Rodin was Léon Maillard, who in 1899 published a lengthy reflection on the statue that probably came out of conversations with Rodin and that has some overtones of Mauclair's article.

This prophetic statue may carry in itself the attributes of the author of *The Divine Comedy*, but it is still more completely the representation of *Penseur*. Freed of the clothing that would have made him a slave to a specific time, he is not only, in his severe nudity, the image of eternal reflection on things human. He is the perpetual dreamer who perceives the future in the facts of the past, without detaching himself from the noisy life around him and in which he participates, searching to understand all the lamentations and to comprehend all of the failures. In this superior figure, Rodin was inspired by Virgil's companion in Hell: it was under the aegis of Dante that he modelled *The Thinker*; but by the privilege of genius, and obeying obstinately the true direction of his art, he leads this figure to a more complete significance conforming to the immensity of the sensations with which the spectacle revealed itself in moving compositions. From a specific and known being he has been transformed into a moral type. Also, the seated man, knees apart, the torso bent forward, the fist brought to the lips, is the strong man, of solid structure, who does not weaken under the facts of so much suffering of which he is the witness. Whether this be Dante, or the human identification of Thought, his visionary look follows the evolution of weaknesses and passions through fabulous times, when humanity would furnish heroes for Olympus, down to the most recent times of which he has been a part.[42]

In 1900 after a visit to Rodin, writer Serge Basset described *The Thinker*: "In the center of the tympanum and seated on a broken column, symbol of ambitions never satisfied, a thinker, proud and sad, dreams, in his chaste nudity. His revery evokes the frightening population further on."[43] Two years later, in her first of several books on him, Rodin's close friend Judith Cladel described *The Thinker* as "the somber thickset Poet in his meditation" (p. 52).

Today the most famous of Rodin's contemporary commentators is the Czech poet, Rainer Maria Rilke, whose 1903 essay on the artist was probably the single most influential publication in establishing the sculptor's reputation with European readers in the twentieth century. Rilke's passage on *The Thinker* is at once the most poetic and incisive.

> Before the silent closed room of this surface is placed the figure of "The Thinker," the man who realizes the greatness and terror of the spectacle about him, because he thinks it. He sits absorbed and silent, heavy with thought; with all the strength of an acting man he thinks. His whole body has become head and all the blood in his veins has become brain. He occupies the center of the gate. Above him, on the top of the frame, are three male figures; they stand with heads bent together as though overlooking a great depth; each stretches out an arm and points toward the abyss which drags them downward. The Thinker must bear this weight within himself.[44]

Testifying to the fluidity of interpretation the statue invited, even those who had access to Rodin could not agree on who *The Thinker* was and what he was doing. Before 1903 he was a "superhuman" or "thoughtful Dante" capable of "deep understanding" of the human soul or he was "an awful Thinker" like "a bird of prey . . . contented in the vengeance he has meted out to the vile of the earth." He was "frightened himself by his work" and a suffering "martyr to his own vision." He was not just a "poet," but an "eternal poet," an "observer," a "perpetual dreamer" about the past and the future. Depending upon whom one read, he had an "inspired gaze," a "rapt and sinister countenance," "looked down on hell," or with "eyes fixed on the infinite" he was "serene in his release from sorrow." He was seen to be "crouching" or sitting on a "broken column," "head in hands," pressing his "fists against his teeth," or "his brain to the limit." He participated in the "noisy life around him," and he was "absorbed and silent." *The Thinker* was "heavy with thought" and "the personification of thought." He was seen to be "reflecting on man and things human," while another writer read his "visionary" look as an indication that he was a morally "strong man" who was a "witness to suffering." Many agreed that he realized the subject of the

great sculpture portal in his thought, and one perceptively recognized his centrality to the "decorative unity" of the great composition.

Who Is "The Thinker" within "The Gates of Hell"?

The Gates of Hell were never bronze cast in Rodin's lifetime because the government never called for them to be delivered. In the last months before his death in November 1917, under the supervision of the first conservateur of the Musée Rodin, Léonce Bénédite, the portal was reassembled in plaster without difficulty. Rodin had worked on his commission intermittently but intensively from 1880 until the spring of 1900, at which time he exhibited the work, without many of its figures in high relief, during his one-man Paris retrospective in June. Although it remained in his studio for the next seventeen years, there is no convincing evidence that he made any significant changes in it. What we see today is what the public would have seen in 1900 had he shown the fully assembled work. *The Gates of Hell* as we know them in their bronze casts are complete[45] (fig. 39). At this juncture we should consider the meaning of *The Thinker* in its original context, for after its enlargement the statue led a different existence, not just for the critics and the public, but for Rodin as well.

Within the portal are fused Rodin's meditations on the human condition, ideas drawn from writers of many ages including his own, as well as from his personal experiences with art and life. *The Gates of Hell* are about the victimization of humanity by its passions and the inability to find peace and happiness past or present, in this life and the next. Rodin's hell is not a place but the condition of being without hope. The infernal is internal. Within *The Gates*, *The Thinker* sits apart, not just because he is still, but also because he alone thinks (fig. 40). As they come to the gate of Hell, Virgil says to Dante, "We are come to the place where I told thee thou shouldst see the wretched people, who have lost the good of intellect."[46] Alone in Rodin's *Gates of Hell*, *The Thinker*, who represents the worker-artist-poet, demonstrates "the good of intellect." Because in society he alone is thoughtful, the artist can detach

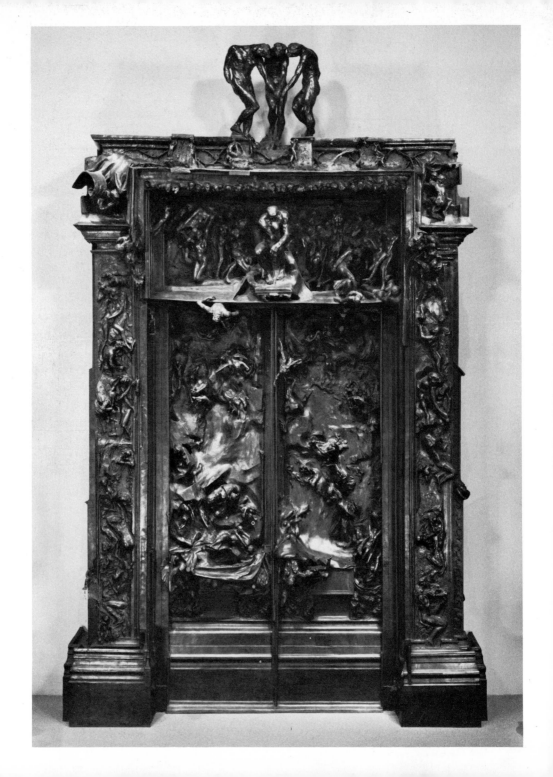

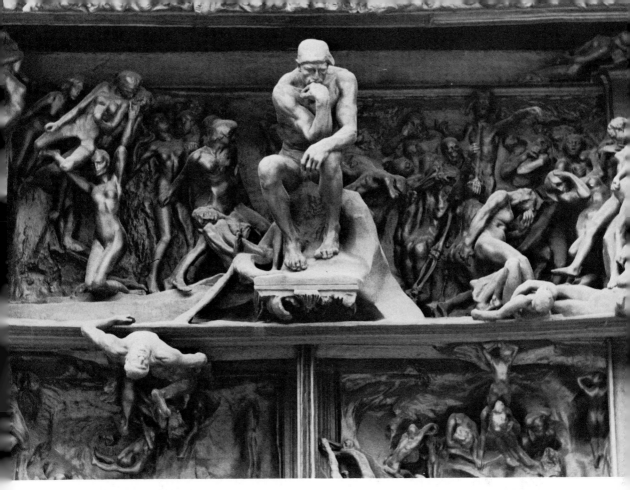

40 Detail of *The Gates of Hell* showing *The Thinker*.

himself from the crowd and its passions in order to reveal humanity to itself. *The Thinker* has replaced God and Christ in the supreme juror's seat, and what is around him is not his sentence for humanity but rather what he judges to be the human condition: one of ceaseless, futile striving.

V. IMP.
INTRO ?

39 Rodin, *The Gates of Hell*, bronze (cast 1980–81), 1880–1900, The B. G. Cantor Collections.

41 (overleaf) *The Thinker* in *The Gates of Hell*, view from below.

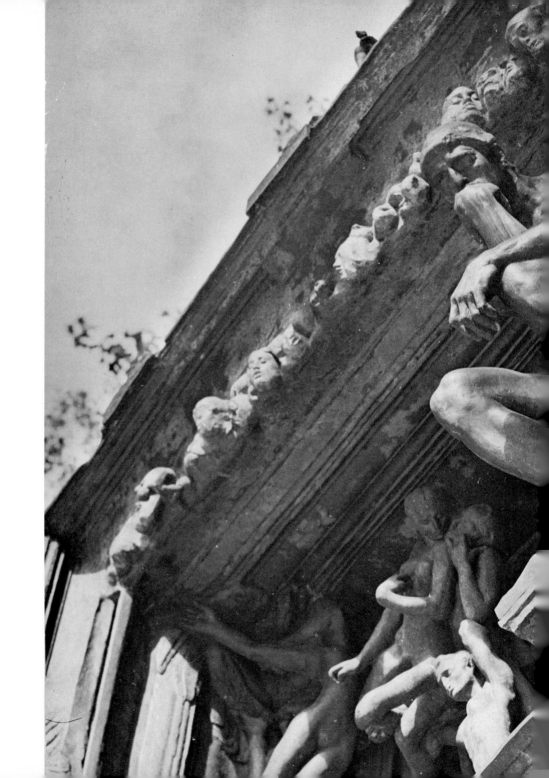

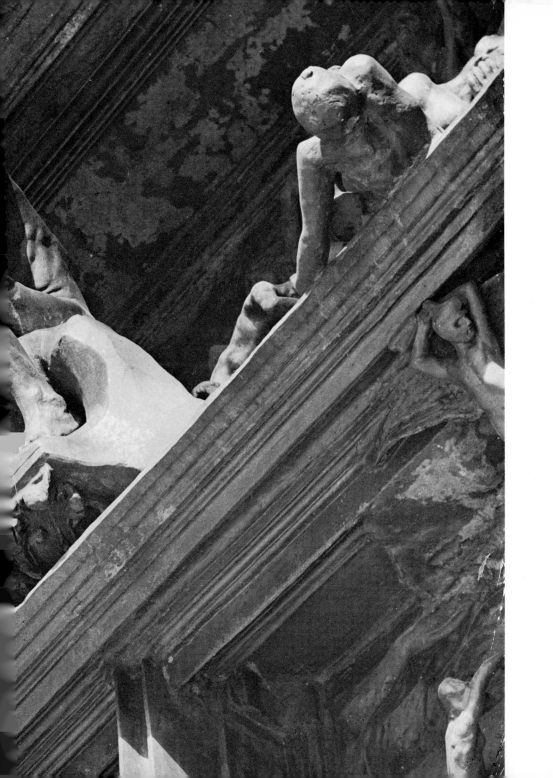

To understand more fully *The Thinker* as the creator and what is required of the creative artist, look again at the sculpture. By placing his right hand against his mouth, *The Thinker* forecloses speech. His lack of irises denies the man sight. Although the ears are not covered, he hears nothing but the soundings of his thought. Without a scrotum he cannot reproduce himself biologically, only through art. It was no coincidence that Rodin shut off the figure's ability to perceive sensation.[47] These decisions, coupled with the over-all pose, compel *The Thinker*'s complete intellectual absorption. He is an image of the sensory isolation required of the most intense creative thinking.

Despite the physicality of the man, the sculpture's focus is upon the brain as the center of creation. Hard thought must come before and after the physical work of art. To win that focus, Rodin bent the head forward and down and shaped the hair into a domical form that attracts light to it. Depending upon the orientation of the doors, the moment the sun rises or moves past the portal's flanks one of the first things it strikes is the head of *The Thinker*. To counter the shadow thrown by the large overhanging cornice above the figure, Rodin actually set him forward so that the base extends beyond the floor of the tympanum and into space. For this reason Rodin modelled foliate decoration for the bottom of the sculpture's socle that can be seen from below (fig. 41). If the patina has not been too dulled by corrosion, when the sun strikes *The Thinker* the cranium becomes an almost luminous orb framed by and surmounting the shoulders. This creative center is the source and climax of *The Gates of Hell*.

The Thinker in *The Gates* is a spiritual portrait of Rodin and of all artists. His own portrait as creator of the work is located in the lower right jamb of the portal, seen as one stands before it (fig. 42). The original commission would have placed the doors at the entrance to a museum of decorative arts, and with *The Thinker*, Rodin was paying personal and public tribute to his profession. In fine, within *The Gates*, *The Thinker* is the artist, and he is thinking about art and life.

42 Rodin, Self-portrait in the lower right jamb of *The Gates of Hell*. He is holding either one of his creations or a muse.

PART TWO

The Dilemmas of Modern Public Sculpture

By August 1901, Rodin had made the decision to enlarge "The Thinker" from its original twenty-seven-inch height to seventy-nine inches. Although Rodin had made many of his important sculptural discoveries in small works and was the artist most responsible for winning acceptance of the étude as a complete work of art, his strong traditional background caused him to continue to regard life-size statues as important for public art. He believed, in addition, that such works were important for his own growing world-wide reputation, which had been given a substantial impetus by his successful retrospective of 1900.[1] Rodin's decision to enlarge *The Thinker* was influenced by many things. First, the sculpture was pivotal to his formal development. It was the means by which he came to terms with ancient art and the art of Michelangelo while creating a personal modern image, as even his antagonists admitted. Second, it was a crucial thematic work in *The Gates of Hell*, by which Rodin had shown the role of the modern artist in society. Critics had discussed the conception, identity, and purpose of *The Thinker* in the portal, but really nothing had been said about its artistic qualities. For example, there had not been a single criticism of the pensive figure's muscularity, which would provide Rodin's critics with so much to write about in 1904 and thereafter. Rodin's practice of making almost all of his figures for *The Gates* in the round meant

the works could have a separate existence and could be enlarged—a reminder of the frugality of genius. As Rodin had done some of his most inspired modeling in figures for the portal, it is not surprising that he wanted to reap the benefits by augmenting their size and offering them as self-sufficient works. There is evidence that in the 1890s Rodin was able to sell casts of *The Thinker*, whether in bronze or plaster is not always clear. (In 1898, however, he did sell a bronze cast to the National Gallery in Oslo.) The sales potential of the work may have also influenced his decision in 1901. Furthermore, the government had made no move to require the portal be cast, which meant that many of his most important figures would not be seen if he did not continue to exhibit them independently. What he had been paid by the Ministry of Public Instruction to cover costs of *The Gates* was not even half of his expenses, and successful sale of big sculptures such as *The Thinker* helped to recoup his out-of-pocket expenses.

Enlarging and Casting "The Thinker"

Today it is customary practice for many sculptors to produce only models for public sculptures. These models are then enlarged by metalworking companies subject to the artist's approval. In the case of abstract sculpture consisting of large planer metal sheets, this practice raises no questions. Many are surprised to learn that Rodin did not personally model his enlargements, but turned them over to skilled technicians. No other sculptor in history is more known for his personal "touch" in modeling surfaces than Rodin, and there may be those who are either uneasy with or sometimes reject enlargements made by his assistants, although such was never the case in Rodin's lifetime. Rodin did not invent the practice of having technicians change the size of a sculpture; for it was known and used since antiquity. He seems to have been one of the first, however, who did not restrict the use of what is known as the *pointing method* to reductions from full scale sculptures. Confident in the skill of his technicians and his own capacity to supervise their work in process, in order to save time, Rodin used surrogates to enlarge his small plasters from at least the 1880s, when he could afford their skills. From

the early 1890s, he had the almost exclusive services of Henri Lebossé, a professional "reducteur" who prided himself on being able to reproduce Rodin's personal touch[2] (fig. 43). Lebossé enlarged *The Monument to Balzac* and, according to his file in the archives of the Musée Rodin, he asked to begin work on *The Thinker* in August 1901.

Lebossé and other sculpture "reproducers" employed variations on the Colas machine, which operates like a pantograph. The model to be enlarged or reduced is placed on one turntable and a blank of clay on another that is joined to the first (fig. 44). Using a stylus linked to a sharp cutting knife, the technician makes a succession of vertical tracings of the model's profiles. These are instantly repeated by the action of the knife cutting into the blank, which had been roughly shaped into the configuration of the work to be reproduced. Eventually all of the profiles have been retraced and cut, and the technician needs only to remove the excess clay from the blank and touch it up with his fingers. In general this was and is a mechanical operation, but not in the case of enlargements made of Rodin's works. Repeatedly, Lebossé's notes speak of his redoing a *morceau* or fragment, since a figure such as *The Thinker* was done sequentially—head, torso, and then each limb. Problems arose for Lebossé because he had to more than double the size of the figure, and small complex modeling passages proved difficult to enlarge to the artist's satisfaction. At times Rodin would visit Lebossé's studio, often at the technician's request, to inspect the progress of the work and to give verbal instructions. Other artists also came to see the progress of the enlarging of a major work such as *The Thinker*; which was by no means a clandestine activity.

In the years after 1900, Lebossé often worked simultaneously on several works for Rodin, sometimes with the help of his assistants. The difficulty of the assignments and meeting Rodin's exacting standards were such that Lebossé stopped giving the work of enlarging to assistants and did it himself, setting up a separate studio just for Rodin's projects and for stretches of time refusing work from other clients. His written notes to Rodin give us a tantalizing but skeletal descriptive chronology of how *The Thinker* was enlarged.

(8/22/1901) "I am also occupied with *The Thinker*, but . . . I must wait until September or the beginning of October to present you with 'un magistrale morceau.' " (10/17/1901) "This time I think you will be entirely satisfied. . . .

43 Henri Lebossé effecting the montage of the enlarged version of
Rodin's *Ugolino and His Children*.

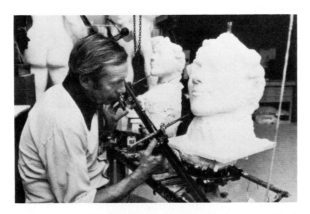

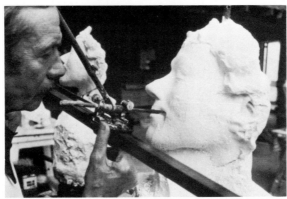

44 A present-day sculptural reproducer working on one of the same
machines used by Lebossé to enlarge Rodin's *Thinker*.

when it is mounted I dare to tell you it will be perhaps the morceau of sculpture most important for your work." Lebossé may have been referring here to the head of *The Thinker*. Rodin may have been very busy or may have needed time to consider what Lebossé had done before giving authorization to make the full figure. This may explain the time that elapsed before this sculpture is mentioned again.

(4/25/1902) "I will not be able to finish *The Thinker* till the end of the year." Lebossé was also working on the enlargement of Rodin's *Ugolino*, and this project seems to have preempted work on *The Thinker* for some time. (5/23/1901) "I would like your order to prepare *The Thinker*." (7/2/1902) "I will now get to work on *The Thinker*." (9/4/1902) Rodin's assistant Guiochet had reported to Rodin about Lebossé's difficulties, and Lebossé wanted to reassure his client he was not neglected. "I could present a large fragment." (9/19/02) "I am working on the immense torso of *The Thinker*." Aware of Rodin's impatience, he says that Guiochet has seen it and can make a report. (9/26/03) Lebossé again postpones showing Rodin the torso and says that when Rodin sees it he will understand why it took so long. 'The more I work on your art the more I see its importance and it takes much time to obtain on a large scale the beauty of your modeling." (10/14/04) Lebossé invites Rodin to his studio but worries about showing him something "incomplete." (11/28/04) Lebossé mounts *The Thinker*, putting the head on the torso and the torso on a sculpture stand and calls it "a splendid morceau." (1/9/03) Lebossé is ill and cannot walk or talk, but can work, and needs a few more days for the arms. "I send you one that is dry, the other is too moist for mounting. I will not have need of the torso until around the 25th because the arms are coming along, but there are the legs and they are no small thing."

(2/20/03) Rodin tells Lebossé that he wants to exhibit the full plaster of *The Thinker* in a Salon. Lebossé writes that he doesn't stop work until midnight "to do a work worthy of your talent. One must pay attention and start over many times in order to preserve the character of your modeling. . . . Guiochet has told me he will need a month to make the mold and the casting." (3/1/03) "Your friend Pompon [a sculptor of animals] has been absolutely enthusiastic . . . and he will tell you that he has found that, far from having lost in

the enlargement, your sculpture has taken on a grandiose and animated char-
acter, while scrupulously conserving your particular touch. With all my heart
I hope that will be your opinion. I've had many visits from your admirers
who have been similarly surprised and congratulate you."

In the intervening months Lebossé worked on other sculptures for Rodin,
but on August 9 he wrote that he wanted to show him *The Thinker*'s legs,
which "have been completely transformed." Rodin next wanted to know
when *The Thinker* would be ready to go to the plaster molders and then the
bronze foundry. (8/23/03) "Tomorrow Guiochet will help me detach the first
leg [from the machine] and it will be two weeks before the second is ready.
I want time to make the second leg as good as the first." (8/30/03) Lebossé
tells Rodin that in order to gain time for the foundry he works from 6 A.M.
to midnight, "but I have effected a formidable retouching by doing it over
again entirely. This time I think your work will be complete." He asks Rodin
to visit the studio and suggests that Guiochet take impressions for the molds
while the leg is still on the machine to save time.

At one point in his notes to Rodin, Lebossé made the touching, as well
as prideful comment, "I want to be your perfect collaborator."In the last book
written on Rodin before the artist's death, Gustave Coquiot recounts a story,
perhaps supplied by the artist himself, that after the public installation cer-
emonies of *The Thinker* in 1906, Lebossé complained that he was given no
credit. "Not a word for me!" Rodin is said to have replied benevolently, "But
my dear X . . . take your part of it" (p. 127).

In the reserves of the Musée Rodin at Meudon there is a plaster head of
The Thinker that astonishes those who see it for the first time (fig. 45). Un-
questionably, it is a plaster made from the clay morceau that came off of
Lebossé's machine. It was then cast in plaster by Guiochet, who as one of
Rodin's most trusted and long-time assistants, performed such tasks. This
may have been the trial morceau Lebossé submitted to Rodin at the outset of
the enlargement in 1901. Rodin had the head mounted against a board, as a
relief.[3] As the work stands on the neck, the face is turned upwards. (This
position makes it easier to see that there were no irises indicated in the eyes.)
What may strike some as a patch of exploded bubble gum is in fact the

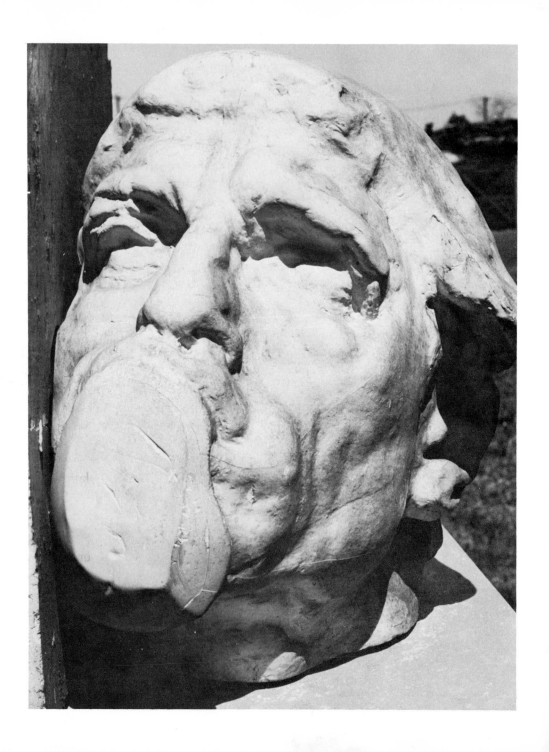

temporary slab placed over *The Thinker*'s mouth by Lebossé, the slab that would later be replaced by the figure's right hand when he effected the final montage of the various parts.

Rodin was inclined to preserve and delight in such "accidents" of the work of art.[4] He seemed to enjoy the unforeseen conjunction of the illusion of nature, which was a goal of his art, with a natural stage in the artistic process. Rodin's modernity resided partly in the self-reflexive aspect of his sculptures. While works such as this were usually not exhibited in commercial galleries and Salons, they were on display continuously in the vitrines of his own Musée Rodin, which his pavilion at Meudon had become since it was first erected for his 1900 exhibition. This pavilion was the mecca for hundreds, if not thousands, in the international art world between 1900 and 1917; so that what to Rodin's public may have seemed a bizarre morceau must have been pondered by many artists. They would have recognized their sources and been interested in their effects.

The foundry to which Lebossé referred in his last notes was that of the young and talented A. A. Hébrard. For reproducing sculptures in bronze, by the turn of the century sand casting had almost entirely replaced the costly, more difficult and time-consuming, but also more precise lost wax process. The famous Alexis Rudier foundry did sand casting, and Rodin preferred it after 1902, but did not use it exclusively.[5] One critic thought worthy of mention in December of 1903 that Hébrard was chosen to undertake the lost wax casting of *The Thinker*: "A young and audacious founder . . . A. A. Hébrard, has undertaken in an amazingly short space of time to cast it in lost wax. The enterprise is hard. Let us hope it will be crowned with success."[6]

Hébrard's dossier in the Musée Rodin archives brings to life what is otherwise a name etched in a bronze cast and shows the maneuvres of an ambitious young businessman dealing with an experienced and wily old professional who had his own ideas about how he wanted to conduct his

45 Rodin, *Head of The Thinker*, plaster, enlarged by Lebossé, with a slab over the chin and mouth where the hand would join the face, Musée Rodin, Meudon.

relations with clients.[7] Furthermore, it sheds welcome light on the micro-history of a major work in the history of art and reminds us how intertwined were art and business for Rodin, who refused to turn commercial matters over to an art dealer, as is customary among sculptors today.

The correspondence concerning the casting of *The Thinker* for an exhibition in St. Louis in early 1904 begins on August 24, 1903, with negotiations on a price that Hébrard vows is a "sacrifice" for him. He writes, "Americans attach great importance to lost wax and pay almost as much for it as marble." He remarks that Americans would know that he cast Rodin's work. On October 9, before he prepares the wax version from the plaster cast, he agrees to let Rodin pay his bill of ten thousand francs for *The Thinker* when it is sold.

The founder puts a studio at the disposal of Rodin's most trusted *patineur*, Limet, who will apply the patina to the bronze cast when it is ready. A special crate to ship the sculpture across the Atlantic must be made, and time is short to get it to customs in Le Havre. Hébrard regrets that Rodin did not see the finished bronze, as he was jealous of the attention given to his sand-casting competitors, and he writes that the cast looks as if Rodin had "modeled in the bronze." Rodin is invited to see the wax version of the second cast when it is dry. On July 28, 1904, Hébrard notes that the second bronze will be delivered to Rodin's studio and asks if Rodin needs the necessary metal to make repairs, because the same bronze must be used as in the casting. Evidently, Rodin was not totally satisfied with reports he had of the first casting, which was shown in St. Louis and purchased by the city of Louisville, Kentucky, and he decided to have the chasing, as well as the patina done at one of his studios.

It also appears that Hébrard asked Rodin to leave the plaster model at his foundry and permit him to make a commercial edition of *The Thinker*. On November 7, 1904, he writes to say he understands that Rodin prefers to receive clients in his own studios and reassures the artist that he will cast from the plasters in his custody only on Rodin's orders. He adds that he would like two clients to visit the sculptor's studio. By December 16, 1904, Hébrard has learned that *The Thinker* will be placed in public in Paris, and he hopes that Rodin will put a lost wax cast in front of the Pantheon. He offers to charge only what a sand cast would cost. (This is evidence of the commercial

war between the two types of foundries, a battle that Hébrard won.) He proposes that each time he has an order he will notify Rodin, make the cast, patinate it, submit it to Rodin for inspection before delivery, and pay the artist one thousand francs. Since he has three or four orders waiting, he would like a reply from Rodin.

The orders Hébrard mentions sometimes came from the directors of big exhibitions, who would contact a founder like Hébrard about showing a bronze such as *The Thinker*. The director would ask a 20 percent commission on sales. Hébrard wanted to exhibit his cast for the Pantheon and asked Rodin for the dimensions of its pedestal. It appears Rodin agreed, and the work was exhibited February 1, 1905.

On January 23, 1905, Hébrard sent Rodin twenty-five thousand francs for the sale of *The Thinker* at the St. Louis exhibition, and Rodin paid his debt of ten thousand francs to the founder. On February 9, 1905, a letter gives an indication of skullduggery in Germany, for despite Rodin's "interdiction," the Berlin house of Keller and Reiner had shown a sand cast of *The Thinker*. (How they obtained a plaster model in order to make the casting is not clear.) Hébrard asked Rodin to write letters to the dealers to stop this exhibition, since he was showing his lost wax cast in the same city, but it appears that attempts to stop it were too late.

The 1904 Paris Debut of the Enlarged "Thinker"

The first public showing of *The Thinker* was in St. Louis in early 1904, and that year it was also exhibited in Dresden, but its most important showing critically was in the spring Paris Salon of the Société Nationale des Beaux-Arts, held in the Grand Palais. The critic Louis Vauxcelles, who would go down in the history of modern art for having given the Fauves their name in 1905, pointed out that there was no immediate outcry over the showing of *The Thinker* as the *clou* or featured work given the place of honor under the glass dome of the rotunda as there had been six years before when *The Monument to Balzac* made its debut. At that time Rodin withdrew his sculpture after two weeks of furor.[8] Vauxcelles, who began his article by referring to

the "quasi super-human work of Rodin," stated succinctly, "This statue commands respect." It did and it didn't. By 1904, Rodin had the support of the most important critics and the sympathy of the public, but Vauxcelles published his comments immediately after the opening of the Salon. There developed in the press a vigorous tattoo of praise and damnation that did not stop when the Salon closed, but continued for years. Unlike the opponents of *The Monument to Balzac* in 1898, those of *The Thinker* usually covered their collective critical arse by professing respect for Rodin's hard work and skill, and recognizing his achievement in small sculptures that were about nothing, as one of them put it.

The Thinker's reception was neither warm or cool, and rare was the critic who was indifferent to it. Some of those favoring the sculpture saw it in terms of the artist himself. After warning readers that the sculptural figure "is hardly an elegant ideologue, effortlessly bringing together fine thoughts," Vauxcelles added: "*The Thinker* represents thought itself, the happy tortures of the mind that leads the world, the concentrated and creative meditation of an Aristotle, a Leonardo de Vinci, a Leibniz, a Kepler, a Pasteur, a Renan, a Rodin."

A writer named Ulla, who knew Rodin and saw the statue in his studio and possibly at the St. Louis exhibition, wrote on March 26, 1904 in *La Guepe*, a New Orleans paper, "His model would seem to belong to the people, to the peasant accustomed to bending over as he watered the earth with his burning sweat.... The artist, no less robust, standing in front of his work, approaches it in the similarity of proportions; solid, firm regard, stable, he seems legitimately proud of his Thinker of which the appearance harmonizes with the perfect ensemble of proportions and the attitude of this man, who is evidently delivered from mighty reflections."

In his book on Rodin published in 1905, Camille Mauclair, who referred to the artist as a "gloomy psychologist of passion," also made the equation between creation and creator: "Bending over life and over his work, he is himself his own *Thinker*, attentive and reverent before an unknown and terrible divinity. Never did any other sculptor attempt to vivify his art with such intellectual superiority and by such meditations."[9]

What proved to be the most controversial aspect of *The Thinker*, his powerful muscular form, had its admirers as well as detractors. Roger Milès ap-

proved: "The naked man is seated: he is brawny, solid of frame; he has physical strength; a blow from his robust fist could kill an ox. . . . He expresses this impalpable thing, this fugitive and tenacious thing. . . . He thinks! He has no awareness of his material being; his head bows under the immense burden of the idea, and with his right elbow resting on his left knee he supports his head where a world is in agitation, where life is stirring."

Achille Ségard seconded this endorsement but with a slightly different interpretation. "It is the great and magnificent body of a naked man, larger than life-size, and seated on a rock. The torso leans forward, the chin resting heavily on the hand and an elbow that drives into the knee. The entire attitude expresses hesitation. But one feels that this hesitation will be of short duration. . . . The whole body is waiting, like that of someone about to rise, to walk, and to act."

An anonymous detractor found in *The Thinker* a "glacial welcome," and added, "It is truly genius by the ton, but what coldness, gentlemen, and as I understand it this refrigerator is destined for *The Gates of Hell!*"[10]

A second unsigned writer set the tone for the adversaries of the low-browed figural type and the pose and reminds us of the prevalence of physiognomic psychology in Rodin's era:

This inclined and meditative giant whose front hangs over the abyss is obviously imposing. It seems that he looks down on the crowds from the height of a cathedral. But he would be more at ease to abandon himself in reveries if the artist had given him a more natural pose. To lean his head on his hand and rest his arm on his thigh is well enough; but to chose his left thigh in order to serve as the base for his right arm, that is to me a paradoxical gesture. "Our dignity resides in thought," said Pascal. Could we not add that ordinarily thought reflects its dignity on the forehead, the features of a man who lives by the mind? Now, I do not see traces of thought on this low and narrow brow. The pose expresses meditation sufficiently. But it also expresses lassitude, boredom, disgust. In order for me to recognize a thinker in that attitude, it is necessary that his face show an enlightenment that is not there. This rugged man seems to me to be a malcontent who ruminates on his anger, rather than a sage whose thoughts fly on lofty summits.[11]

Some writers were aware of the statue's origins and commented on the effect of the enlargement. Rodin's former English secretary, Frederick Lawton, wrote, "If in the enlarged and isolated figure, the idea loses some of its particular reference, it gains in grandeur. On account of the vast proportions, the muscularity of the man is intruded on the notice, causing the profane to scoff and to query why a thinker needs such brawn" (p. 47). Lawton's observation is astute, because when the figure was seen mounted in *The Gates* earlier, his muscularity was not remarked by critics.

Thiébault-Sisson alerted his readers to the fact that "the first idea for *The Thinker* is not recent. Rodin had formulated it earlier a long time ago, in a small figure which surmounts his *Gates of Hell*. But in giving to it colossal proportions, he has happily modified it by his corrections of details and he offers us an entirely new work." Just what details were modified the writer does not say, nor are they apparent by actual comparison between casts of the two sizes. Thiébault-Sisson was writing from memory and in his enthusiasm for the work may have subconsciously felt the need to assure the public that the statue had more than a technical difference from its model. No critic, however, had raised this issue.

The most perceptive and interesting distinction made between *The Thinker* inside and *The Thinker* outside *The Gates* appeared in the December 17, 1904 issue of *Revue Bleue*. In an article titled "Le Penseur de Rodin au Panthéon," Gustave Geffroy saw the figure transformed from the social conscience of his age to an invincible man:

> What in effect is the *Thinker*? It is a man in all the force of action who has stopped in order to dream. Originally he was at the summit of *The Gates of Hell*, the figure of the poet who contemplates the passionate agitation of humans. This conflict was reflected in him: he sought to be aware of life and it is truly in that sense of his attitude that he is the Thinker or Poet. But isolated, as he has been seen in the Salon, as one can dream of him in a public place in Paris, he takes on an attitude determined more by action than repose. His strength, his musculature, his modern Herculean appearance dispel the idea that this formidable being will rest forever immobile and suspicious, lost in the infinite abyss of his contemplation and revery. They have said, believing it to be a criticism, that he thought "with his back." Yes,

certainly, he thinks with all of his being and he gives at once the idea of fatigue and of recommencing his effort. . . . It appears that if he would rise and march, his legs would shake the soil and the ranks of an army would open before him.

In the first reviews, not surprisingly, most of the critics focused on the relationship of *Le Penseur* to *Il Pensieroso*, Michelangelo's statue of Lorenzo de' Medici, using this comparison to praise or damn Rodin's work. Achille Ségard reckoned Rodin as the only contemporary sculptor who could support comparison with Michelangelo. He attributed the crossing over of the right elbow to Michelangelo's figure of *Night* in the Medici tomb, and he recognized that Rodin's figure was "less elegant, less proud, but a secret movement animates the two." Thiébault-Sisson saw in *The Thinker* "a more modern inspiration, and a shiver runs through *The Thinker* that the work of Carpeaux and Michelangelo never knew. It is a nervous and taut art of *The Age of Bronze* with perhaps more suppleness and greater serenity."

In 1904 statues were still reviewed as if they were actual human beings or characters in a play. What they stood for in terms of their time was to be taken seriously whether the writer liked the sculpture or not. Statues were still considered guardians of public decorum and morality and conveyers of ideals such as patriotism, as well as the last defense of "true" beauty that painting had abandoned with the rise of Impressionism. Ars Alexandre, a modernist, accordingly characterized the differences between *The Thinker* and his time, and Michelangelo and the Renaissance:

Our epoch is forced to say much more to express as much. We are no longer in the time when one could be strong without effort. Today, thought is devoted to bitterness, to distresses, to the crushing. The most rough and austere conceptions of Michelangelo are calm and serene compared to those we have at present. The heroes and thinkers of the great Florentine are saddened by the memory of light. This thinker by Rodin seems to have known only shadow.

Pierre Bouillet echoed Alexandre's characterization of Michelangelo's art as epitomizing a "noble attitude," a "serene and calm philosophy," but stated

that because of the "academic beauty" of Lorenzo's gesture, "the contour and form count for more than the thought." The writer then made the surprising statement that Michelangelo "is Greek by origin and not from the soil of the condottiere. He is neither of his time or his race." In contrast, Bouillet saw in Rodin's "nude colossus" that

> The thought is profound and dolorous. . . . it seems to embrace all of humanity. . . . [*The Thinker*] summarizes all the agitations of our tormented epoch, all the struggles and fevers, all the uneasiness and distress. The figure evokes the idea of a prodigious force, moving and tragic. It is a man come to grips with the powerful forces of nature. In order to win, there must be the continuous tension of the muscles and his brain. The synthesis of life in a modern city: such is *The Thinker*

One of Rodin's more bitter critics, L. Augé de Lassus, commented that Rodin's *Thinker* thinks different thoughts than Lorenzo, "because he is a man of our day." After comparing the "undressed hair" of the former to the helmet of the latter, de Lassus complains that he has trouble imagining the thought of Rodin's figure or believing that "he can think of anything. Is he thinking of the fugitive promise of workers' pensions? His nakedness causes us to suppose that he is really destitute." The same writer saw the parentage of *The Thinker* in Carpeaux's *Ugolino* and points out that it also recalls the art of Pierre Puget with its "formidable musculatures." De Lassus viewed this seventeenth-century sculptor as operating "more within anatomical truth" when compared with Rodin's "uncorrected surface irregularities" that evoke "violent brutality."

The Miner (fig. 46), by the Belgian sculptor Constantine Meunier, shown at the same time as *The Thinker*, was used by another of Rodin's conservative adversaries, Gabriel Boissy, as a model of what a modern sculpture should be:

46 Constantin Meunier, *The Miner*, bronze, the Salon of 1904.

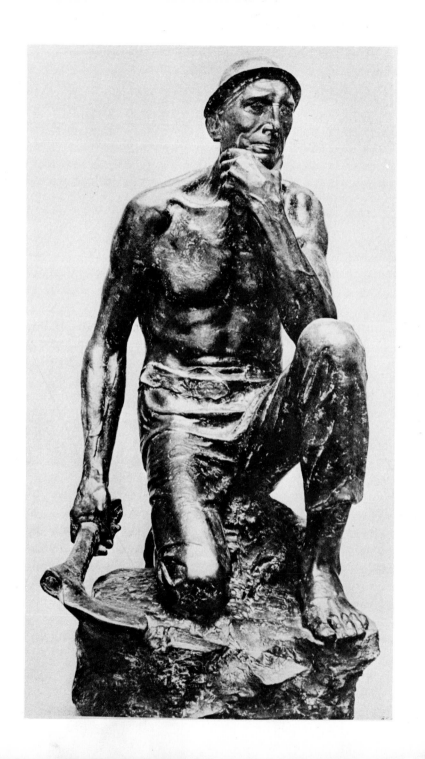

The Miner of M. Constantine Meunier is something else. Here . . . we are elevated because the subject is seen with all the perfection to which it is susceptible. This personage is not a hero: he does not accomplish an idea but rather a function. Only he accomplishes it with such fervor, he is treated in such schematic fashion as to become a symbol. This theme, without its own beauty, without lyricism, achieves lyricism and beauty by the manner in which it is executed and that consists in pushing all form, even the most vulgar, to style. . . . With a single personage, Constantine Meunier evokes an entire population; he succeeds in giving form to the worker's emotion before work, the meditation . . . before the effort; he realizes all the nobility, all the beauty possible in this motif; he created a type; he has thus accomplished his duty as an artist. M. Rodin degrades the mind; M. Meunier idealizes the worker, the former is decadent, the other is eminently social.

Boissy's attitude represented the point of view of Rodin's habitual enemy, "The School," or the Ecole des Beaux-Arts, which was attempting to appear modern, to bring its ideals into the twentieth century, by accepting a plebeian subject while maintaining its traditional view that sculpture should raise the particular to the general or the individual to the type, express noble sentiments in appropriate poses, and through a perfected, finished form elevate what was intrinsically vulgar to beauty by means of style. Rodin did not believe that anything in nature or life was ugly, but only that there was bad sculpture. His convictions about truth caused him to reject idealization as untruthful, and he had his own convictions about decorum.

By 1904, Rodin believed in artistic completeness rather than finish and detested self-consciousness about style. He had demonstrated with *The Age of Bronze* and *St. John the Baptist* that he was capable of what was called in contracts between artists and clients "a Salon finish." *The Thinker* was first made in 1880, when Rodin accepted this norm for a public statue, and the enlargement did not change its style. It was in his work long after 1880, notably in *The Monument to Balzac*, his études and partial figures, that he broadened his own criteria and rejected sustained detailed facture. Incomprehensible as it may seem to us, there were those who looked upon *The Thinker* as an unfinished work, a preliminary study! Marcel Hennequin chastised Rodin

because he "diminishes his genius by the public display of this execrable sketch."

The same unnamed critic who berated *The Thinker* for not showing facial enlightenment added, "Perhaps if the statue was finished it would success-fully respond to our critique. . . . Sketches have their beauty, but on the con-dition that they do not usurp the rights of definitive works. This is a usurpation by a sketch to substitute itself for the promised and awaited statue. The state of the sketch is not for the statue."

Even before the statue was exhibited, Thiébault-Sisson saw it in the studio and went to some pains to reassure his readers that what Rodin was saying through the tension of the figure was expressed "in precise characters that the smallest details of the execution accentuate." Perhaps knowing Rodin's controversial reputation with respect to the "finish" of a work, he added, "The execution is as thought out as possible. Nothing has been left to chance; but the detail has been written with a prodigious completeness. . . . With a visible care for harmony and of composition, the artist has graduated the effects, subordinating the accents to one another. And that is beautiful."

There were many more types of critical support and criticism in connection with the 1904 Salon exhibition of *The Thinker*, but these will be soon discussed in relation to how this statue epitomized present day problems associated with placing modern sculpture in public places.

Installing "The Thinker" in Public

The Public Subscription. Among the visitors to the spring Salon of 1904 was a writer named Gabriel Mourey, who had just launched a new magazine, *Les Arts de la Vie.* One of Mourey's friends was Gustave Geffroy, perhaps the most important and finest French art critic, who had published the most influential articles on Rodin and *The Gates of Hell.* These men and a few of their friends made more than one visit to the central area, circled with hedges with benches placed about, under the rotunda where *The Thinker* dominated the Salon. According to Geffroy's 1904 article, Mourey conceived the idea of

a subscription to keep a cast of *The Thinker* in Paris the moment he saw it when the Salon opened in May.

> There were some who regretted seeing this significant statue returned to the studio, or to an English or American city more hospitable than Paris to the productions of French genius. It seemed simple to keep this Thinker if we had wanted to. . . . It is probable that a subscription undertaken by all the newspapers would have succeeded to this end. But our newspapers are directed by industrialists who care only for great affairs or by political men who do not have time to participate in the melees of today. One could not count on the newspapers, and the small review, completely new, still obscure, has done well to act with urgency.

In his new magazine, Mourey wrote of his vow regarding this sculpture:

> This statue of *The Thinker*, I dream of it, raised on a simple granite cube in the center of Paris, amidst the whirlwind of this tumultuous city, because it does not evoke the traits of a dead person, but of someone living yesterday, today, tomorrow, always. It is not a man that it glorifies, but Man in that which he is most sad and great. Yes, I dream of it, this thrilling figuration of the only creative force, eternally fertile, Thought, dominating like unshakeable rock the tumult of our fevers, our vanities, our lies, our prejudices, errors, enthusiasms and foolishness . . . that one not close it in the sepulchre of a museum, that one erect it in the heart even of life! All must see it, at every hour, and that gives its beautiful teaching of health and of the ideal."[12]

Mourey put his finger on what makes *The Thinker* a modern sculpture—it does not celebrate the dead or those who die for a noble cause, but rather life and creation.

In June Mourey used his magazine to launch a public subscription to raise the necessary funds to place the statue permanently outdoors in Paris (fig. 47). Gustave Geffroy was the treasurer, and a Patronage Committee was

47 Subscription form published by *Les Arts de la Vie* for *Le Penseur*.

Les Arts de la Vie

REVUE MENSUELLE

6, Chaussée-d'Antin Gabriel MOUREY, Directeur

SOUSCRIPTION

pour offrir au Peuple de Paris

" Le Penseur "

D'Auguste RODIN

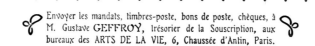

Envoyer les mandats, timbres-poste, bons de poste, chèques, à M. Gustave GEFFROY, trésorier de la Souscription, aux bureaux des ARTS DE LA VIE, 6, Chaussée d'Antin, Paris.

Je soussigné ..

..

demeurant à ..

.. *déclare participer*

pour la somme de ..

à la Souscription organisée par les ARTS DE LA VIE *pour*
l'acquisition du « Penseur », de Rodin.

.. *le* ..

Signature :

Dans le prochain numéro des ARTS DE LA VIE (Juin), seront publiés les noms des membres du Comité de la Souscription « Le Penseur », la liste des souscripteurs et les lettres d'adhésion des personnalités de l'art, de la science, de la littérature et de la politique qui s'associent à notre initiative.

formed which included such artists as Claude Monet, John Singer Sargent, Felix Bracquemond, Max Klinger, Max Liebermann (president of the Berlin Secession), Constantine Meunier, Jules Cheret, Eugene Carrière, and Emil Bourdelle. Included in this group was Jean Paul Laurens, a painter and member of the Institute of France. The committee also counted among its members such elected government officials as deputies Pierre Baudin, Léon Bourgeois, and Marcel Sembat, Senator Robert Poincaré, member of Parliament George Wyndham, two members of the Paris Municipal Council; the directors of several powerful Paris papers, notably Henri Rochefort of *l'Intransigeant*, and those for *La Presse, l'Echo de Paris, Le Journal*, and *Gil Blas*; former government art officials who had supported Rodin, such as Antonin Proust and Edmond Turquet, the actual commissioner of *The Gates of Hell*; the distinguished German art patron Count von Kessler; and writers and poets, including Arthur Symons, Emile Verhaeren, and Octave Mirbeau. Many must have been surprised to see on the list the name of Jean Prévost, the director of La Société des Gens de Lettres, which had rejected Rodin's *Balzac* six years earlier. The French Academy of Sciences was represented by its secretary, the distinguished chemist Marcellin Berthelot, a personal friend whose portrait Rodin would model and exhibit in 1906. In sum, Mourey and Geffroy had put together a blue-ribbon sponsoring group that cut across the various professions, political views, and national boundaries, and there is no doubt but that Rodin was thus assured of a good press from major publications.

La Liberté, whose director was not on the subscription committee, gave Rodin a sardonic compliment for the makeup of his support on June 1, 1904: "Today Rodin is an excellent artisan of national reconciliation. The committee that is being formed in order to buy *The Thinker* is composed of the best enemies in the world. For example: Ranc and Jules Lemaitre; Mirbeau and Denys Cochin; Henri Letellier and Henri Turot, and Joseph Reinach and Henri Rochefort."[13] Rodin was mindful of the values of a many-leveled bipartisan support group, as he had suffered during the *Balzac* affair because many of his supporters were pro-Dreyfus, and Emile Zola was angry that the beleaguered Rodin did not publicly support the unjustly accused Jewish army officer. In his letter of thanks to Mourey and his colleagues, published in the December 1904 issue of *Les Arts de la Vie*, Rodin made this point, "You have

composed a committee without political color, that gives to my subscription a true value."

After the close of the spring Salon, the plaster cast of *The Thinker* was placed on public view in the Trocadero Museum which was later torn down and replaced by the Palais de Chaillot. No deadline seems to have been set for raising the funds, but there was naturally concern that for the reputation of the artist and the committee it not be protracted. To the satisfaction of the project's supporters, the subscription was filled by December or in about six months.[14] Rodin found the total of more than fifteen thousand francs "a very suitable sum." It covered the costs of work in the studio, the bronze cast, a stone pedestal, and installation with little or no financial profit to the sculptor. Rodin knew, however, that this project would increase demand for casts of the work.

Many artists beside those on the committee contributed to the project, including sculptors Jane Poupelet, the Schnegg brothers, Carl Milles, and Charles Despiau, and painters Fernand Khnopf, Henri Edmond Cross, and Jacques Emile Blanche. The names of Marcel Proust, the great writer, and Daniel Henri Kahnweiler, a young art dealer, whose greatness was still to come, appeared on the long subscribers list. At the last hour, one-third of the total was raised by large donations from two of Rodin's private benefactors, Baron Vitta and Madame Fenaille, who gave two thousand francs each. One thousand francs were given by the Ministry of Public Instruction, which in effect became the beneficiary of the statue.

Selecting the Site. In his published revery on *The Thinker*, Mourey had written of his hopes to see the statue in the heart of Paris. He and several others wanted it where the crowds were. According to Geffroy's 1904 article, "The first idea of the subscription's promoters was to install the Thinker on one of the public spaces of the more populous quarters of Paris, the Place du Théâtre Français, the Place du Palais Royal, the Place de l'Opera, the Place de la Trinité, etc." At one point it seemed possible that the work might be installed in the square before the Paris Bourse, or stock exchange. Marcel Adam recorded Rodin's reactions and his own thoughts about that location. "The project to place his statue in the square of the Bourse made the sculptor

smile. Before the burning temple of finance, this Thinker, gnawing his fists, would establish a somber allegory."

Adam described Rodin's ideas about the statue's location:

> Now Rodin speaks of his hopes. It is his ambition to see The Thinker facing the Pantheon, at the end of the rue Soufflot, on the round point of the place Médicis [sic]. The master loves that quarter where he lived for so long. Then as a student, he lived on the rue des Fosses St. Jacques; he used to dream in the shade of the trees in the Luxembourg gardens of the colossal work of Jean Goujon. . . . He remembers. He would like to see his *Thinker* in a quarter where he passed his youth studiously. There . . . is the brain of Paris; there in work is formed our future glories."

What Adam did not record was that Rodin had twice failed to have his monument to Victor Hugo placed in the Pantheon. Everyone in Paris knew this, hence the locating of *The Thinker* before this famous building must have been of particular satisfaction to the sculptor.

Accounts vary on how and where Rodin chose to locate the statue. In 1904, Geffroy wrote, "Someone had proposed the Place du Panthéon to him as the solution. The next day it appeared to him, after the examination of the locale, that the statue placed in the center of the large space (of about a dozen meters) that is found between the grill and the stairs of the monument would harmonize with the monument, the high columns, the pavement, the vast place."

The Place de Médicis in front of the Pantheon belonged to the city of Paris. The round point at the intersection of several streets would have been a dramatic location, and it would have allowed Rodin to distance his statue properly from the large portico of the Pantheon so that it would seem larger, rather than smaller. Even though two members of the Paris Municipal Council were on the Patronage Committee, the city fathers rejected this site for *The Thinker*, claiming that it would block traffic.[15] The situation was resolved when, probably at Rodin's tactful suggestion, the Ministry of Public Instruction agreed to install *The Thinker* behind an existing tall, black-painted iron grill immediately in front of the steps of the Pantheon, as that property belonged to the state.[16] Rodin was gracious enough not to express disappointment, even though

in this location *The Thinker* would not literally face the Pantheon and it would be dwarfed by the large building directly behind it. In his letter of thanks to the Patronage Committee, published in the December 1904 issue of *Les Arts et la Vie*, he added his gratitude to the new director of the Ministry of Fine Arts, and the architect of the Pantheon, M. Nénot, "who in looking at the work in place spontaneously gave his assent."

Geffroy may have been an eyewitness to the trial installation on the cold gray morning of November 28, 1904. Three weeks later he wrote:

> A maquette of bronze-colored plaster was installed on a pedestal of simple lines. One would have feared that the statue would have been spoiled or crushed by the gigantic facade. Nothing of the kind. The statue is neither too large nor too small, and the architect in charge of the Pantheon, M. Nénot, judged after a single glance that the work of Rodin was right in scale. It truly seemed that the work had been there as long as the Pantheon. From whatever side one viewed it, from in front, from an angle, or in profile, its massive lines were in accord with the colonnade, the Bibliothèque Sainte Geneviève, the houses.

Poitron's Revenge. The installation of this controversial statue by an equally controversial sculptor before France's secular shrine to its heroes of culture and politics inspired friend and foe to take up their pens and publish their reactions. But on the night of January 16, 1905, the bronze-painted plaster of *The Thinker*, temporarily installed on the site for purposes of study, was smashed to pieces not by a pen, but a hatchet, not by a critic or councilman, but a madman. The January 17, 1905 issue of *Le Journal* carried the account:

> During Sunday evening, a polytechnicien [a student from the nearby Ecole Polytechnique] who passed before the Pantheon warned an officer that an individual was demolishing the statue of *The Thinker*. The officer immediately approached the grills and saw an individual fall at his feet holding a hatchet in his hand, which he brandished while crying, "I avenge myself—I come to avenge myself!" Immediately taken to the precinct headquarters of M. Carpin, he told him the following in the manner of a preamble:
> "First of all, Mr. Commissioner, do not take me for a madman."

M. Carpin, in the most amiable fashion, offered him a chair and asked him to continue.

"It is I, Mr. Commissioner, who discovered the mirror of Archimedes! Related to this subject I sent a detailed memorandum to Mr. Pelletan, who transmitted it to the Great Orient. Following this I was hired and fifteen spiritualists with a chief were put at my disposition. But all of these people bored me. Also, I, who am very clever, pulverized them all. Then, I understood that the hour of deliverance had struck. . . . "

"But," softly interjected M. Carpin, "what does this have to do with the affair of the statue of Rodin?"

"I am going to immediately satisfy your curiosity. Since they erected this statue before the Pantheon, they offended me greatly. Obviously I render homage to the talent of the sculptor: but I regard that it is ironical for me that this statue eats his fist. Because I, monsieur, have only cabbage to eat, and this mimicking gesture of *The Thinker* is a wounding allusion to my misfortune. . . . He had an ugly gesture. I have made a handsome one. The world will judge. Besides, I had decided to do the same vis-à-vis all persons who made the gesture of biting the fist."

M. Carpin, after having assured that only the universe could appreciate such theories, sent under strong escort to the police infirmary this dangerous madman who had given the name of Poitron, "Catholic," former sailor, presently mechanic, living in St. Denis.

The incident must have shocked Rodin and his friends, and it gave his enemies occasion for sarcasm. Even after the bronze cast was installed just before its inauguration, Rodin's assistant Limet took precautions on his own to prevent a recurrence of vandalism that would embarrass his employer at a great moment in his career. In a note to Rodin that must have been written by mid-April, 1906, Limet wrote:

> You will excuse me if I have intervened and brought the police into the installation of your *Thinker*. I have alerted the peace officer in the precinct of the Pantheon. I take the sole responsibility. Your statue is in such a delicate state of balance [on its pedestal] that the slightest effort [to push it over] could have a disastrous effect. I found the peace officer a great admirer of Rodin and the surveillance will continue until the inauguration night and day, and after one must prevent any accident.

The Statue's Pedestal. One of the generalizations about modern art is that it took sculpture off of the pedestal. For many modern sculptors the pedestal had unpleasant connotations: it made the work seem rare or precious and thus self-consciously important; it was undemocratic or authoritarian in connotation; and it had long been associated with celebrating death and the dead, as well as nationalism. Since the ancient Greeks, inscriptions on pedestals were crucial to the sculptural monument, as they identified the subject of the statue and often the hero's achievement in addition to giving the name of the donor. What is forgotten is that many modern sculptors have used pedestals for very practical reasons, to get the sculpture off the ground and up in the air to the proper eye level. Brancusi carved supports for many of his pieces, and while there is dispute over whether they are sculptures, they do function as pedestals. Whether called a base or a pedestal, when used by modern sculptors such as Henry Moore, the supports are severely simple cubes, uninscribed, and not intended to draw attention to themselves. (The modern equivalent of the traditional carved inscription, however, is the bronze plaque, attached to the pedestal by the proud owner, which identifies the work to satisfy the curious public and eventually stains the stone or concrete below it.) Rodin was one of the pioneers in the use of the large, stripped-down stone socle, or pedestal, and his audacity was in initiating this concept with a controversial work of public art.

After *The Thinker* was inaugurated, an unsigned note was published in *La Patrie*, April 22, 1906: "The pedestal is completely simple. Rodin had proscribed all useless decoration and the architect politely contented himself with placing the statue on a foundation of black stone, three steps, and a cube of white stone without ornament." In his dream of the Paris installation for *The Thinker*, Gabriel Mourey wrote of the statue "raised on a simple granite cube." Traditionally, pedestals for public statues were elaborate and usually designed by architects, as had been the base for Rodin's *Burghers of Calais* when it was installed in that city in 1895. It was not unusual for the sculptor who was commissioned to make a monument to be given the depth and width of the work in advance, suggesting that the pedestal was of prime importance. (Rodin was given such measurements for the Calais commission.) Tradition-

ally, an architect would design the horizontal moldings that separated the tiers of the pedestal and that often culminated in a cornice at the top, the inscription, and usually any ornamental features. The sculptor might design a relief for the pedestal that would show the hero in action. (At one time Rodin planned a relief for the future pedestal of *The Monument to Balzac*. He carved almost the entire huge pedestal for *The Monument to Claude Lorrain* into a composition showing Apollo in his chariot.)

Whether Mourey's vision inspired Rodin or whether he talked to Rodin about the project and received the idea from him, we do not know. What is certain is that Rodin was not obliged to work with an architect on the pedestal, although undoubtedly his design had to be approved by the architect of the Pantheon, M. Nénot. Rodin conceived his pedestal in the form of a white cube raised on three white steps and a dark base bearing the simple carved inscription (fig. 48):

> LE PENSEUR
> DE RODIN OFFERT
> PAR SOUSCRIPTION
> PUBLIQUE AU PEUPLE
> DE PARIS MCMVI

For the pedestal's exact design and fabrication the sculptor worked with a civil mining engineer named H. Courtot, who prided himself on his Hydraulic Factory in Neuilly. He specialized in quarrying and cutting stone from Burgundy and Jura that was used for stairways, gravestones, pavements, and balustrades. In January 1906, the sculptor provided Courtot with a maquette of the pedestal, after which the engineer wrote to Rodin on January 17, "I have made plans from it and I have even made other studies that will be submitted to you. As for the execution of the work in its entirety, I take full

48 *The Thinker* installed before the Pantheon on the pedestal made by
 Courtot with the inscription designed by Rodin.

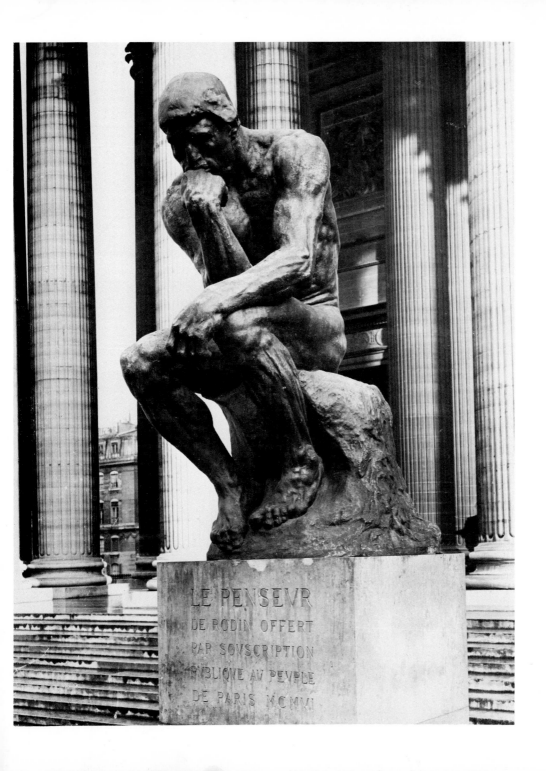

LE PENSEVR
DE RODIN OFFERT
PAR SOVSCRIPTION
PVBLIQVE AV PEVPLE
DE PARIS MCMVI

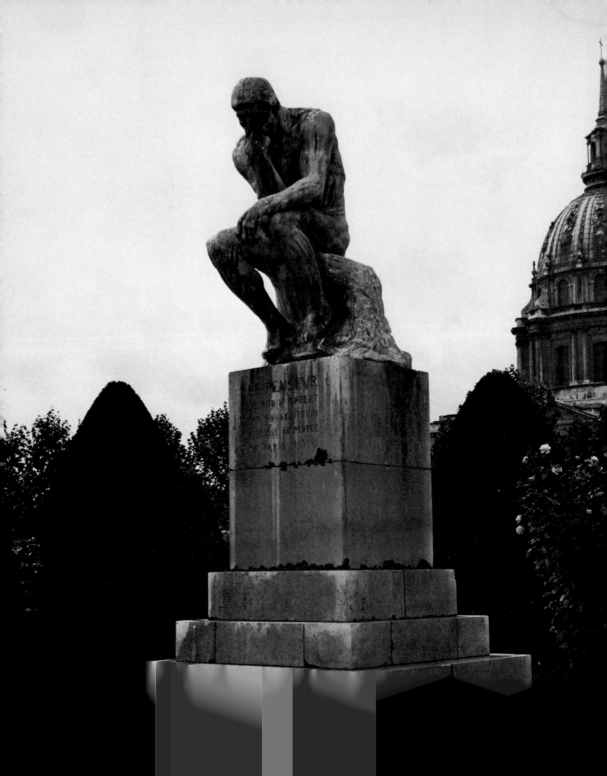

responsibility and put myself completely at your disposal.''[17] By January 25, Courtot had made a half-scale model in plaster to ''give a more exact idea of the effect that it will produce if you will come to look at it when it is convenient.'' The dark volcanic stone for the base, or ''first step,'' came from Volvic, and the white stone from Chateau Landon. Extremely heavy snow delayed quarrying and shipment of the dark stone, but by March 18 the pedestal was ready for installation on the site. In April, Rodin spoke to Courtot about the type of inscription he wanted, and the engineer sent correctly sized examples for study. When Rodin received the bill for Courtot's services in June 1906, the pedestal, as promised, cost 1,450 francs. The supplementary cost for the Volvic stone was 150 francs, the engraving of the letters 115 francs, and the tip for the conçierge of the Pantheon was 40 francs.

The pedestal is ten feet high and today can be seen in the garden of the Paris Musée Rodin (fig. 49). Present-day dislike of tall pedestals, for a variety of reasons having little to do with aesthetics, such as ''putting people on pedestals,'' make Rodin's design a surprise for those who see it. Rodin does not seem to have had a fixed height for his sculptures, as we can see from surviving pedestals for his works in public places. He and the architects with whom he had to work adjusted pedestal heights to the site, as well as the character of the sculpture, but, as at Calais, not always to the artist's satisfaction. Given the original location of *The Thinker* in *The Gates*, about thirteen feet above ground, the ten-foot height for the enlarged figure does not seem so extreme. He had to take into account the large building behind it, as well as consider the optimal viewpoint for the work. Too often the enlarged *Thinker* has been set on a low pedestal. In the forecourt of the California Palace of the Legion of Honor, for example, the pedestal seems to be sinking into the ground under the statue's weight and the statue is not high enough for the viewer to study its intended effect from below.

49 *The Thinker* on its original pedestal, installed in the garden of the Musée Rodin.

"The Thinker" as a Social Symbol

The day before the inauguration of *The Thinker*, a reporter from the newspaper *La Patrie* visited Rodin, and in his unsigned article that appeared two days later, April 22, 1906, he wrote, "I was able to ask of the author of *The Thinker* his feelings about the work and its social significance." Rodin's reply, which seems never to have been reprinted, constitutes one of the rare occasions that he discussed the meaning of this enlarged work and at length.

> My work, why must one speak of it? It magnifies the fertile thought of those humble people of the soil who are nevertheless producers of powerful energies. It is in itself a social symbol and is like the sketch of this *Monument to Labor* that we dream of erecting to the memory of national labor and the workers of France.
>
> All those who believe and grow, do they not take their source of energy from the little and eternal artisans of public riches, from the methodical gleaners of the good grain opposite the sewers of tares? One can never say enough, in this period of social troubles, about how totally different is the mentality of the workers and the spirit of the unemployed of this country.
>
> *The Thinker* on his socle dreams of all these things, and be assured that in him vain utopias will not germinate; there will not come from his lips unpious words; his gesture could not be that of a provocateur abused by false promises.
>
> Yes, let us exalt the little people and tomorrow we will have brought a remedy to social conflict.

The reporter added, "Of the beauty and the truth of *The Thinker*, the master had told me nothing."

Rodin's interpretation of his own work is quite different than his account of 1904, when he described its origins and spoke of the seated figure as being "no longer a dreamer, [but] creator." Given his history of titling severally his own individual works, beginning with the change of *The Vanquished* to *The Age of Bronze*, we are reminded that Rodin's sculptures were not made to

illustrate titles (with the theme coming before the work's creation). The titles were given usually after the work's completion, sometimes by friends, to illustrate the sculpture. Anticipating Picasso's attitude toward his sculpture, Rodin plainly loved to see his art live different lives according to the times and places in which it would be seen, by himself as well as others sympathetic to what he had done.[18] On the eve of the statue's inauguration in Paris before a national shrine, the anonymous reporter had not asked Rodin about his original intentions for *The Thinker*, but about his feelings toward it on April 20, 1906. It is when we put the enlarged *Thinker*, and perhaps the actual decision to enlarge it, into the political and social context of the period from roughly 1901 to 1906 that we may understand what helped to inspire Rodin's feelings about his own work and why he was moved to refer to his sculpture as a social symbol.

The first years of this century in France were characterized by one of the finest historians of that country, Gordon Wright, as being marked by "the most severe labor unrest France had ever known."[19] Writing of the period extending back to 1870 Wright adds, "Almost no other industrial state in those years granted so little to its labor force." Labor unions were not recognized until 1884; women and children were restricted to a ten-hour work day only in 1900; and it was not until 1906 that Sunday was made an obligatory day of rest. The prevailing attitude was one of laissez faire and, as Wright puts it, "the lowest possible tax bill." Neither the middle class nor the peasant class had developed a social conscience, and workers failed to improve their lot by parliamentary means. After 1902 there was a dramatic increase in the number of strikes, the growth of Syndicalism becoming a factor in the period from 1904 to 1907. About the time Rodin decided to enlarge *The Thinker*, there were 22 days of strikes. In 1904 there were 271,097 strikers. In 1906, 435,000 people took part in 1,309 strikes. The length of the strikes often resulted in a lack of food, and the violence that many times accompanied them took a terrible toll. In these same years there was great discontent among the wine workers, and the rural proletariat joined with the urban workers. As Wright remarks, the *internationale* was sung in the Midi, and as it does today, the political right considered this area communist. The climax of this dramatic unrest came on May 1, 1906, when the eight-hour work day was defeated.

As part of the Third Republic's drive to separate church and state, in 1906 the government took over all churches and required an inventory of all church property. This action led to a nationwide rebellion, and after February 1, there was violence as people locked themselves in their churches and government inspectors were attacked. (In the Pyrenees wild bears were chained to the church doors.) Although the Pope urged nonviolence, his followers took his message as an incitement with results that inflamed ultramontanism. In the months before April 1906 in the north, the mines and textile industry witnessed rebellions, and Paris itself saw some of the worst forms of the protest in terms of strikes and demonstrations. The timing of the inauguration of Rodin's *Thinker* came at the very crest of national social and political upheaval, and it is not hard to understand why the conservatives were generally opposed to *The Thinker* and the Socialists supportive. For example, the great founder and leader of the Socialist party, Jean Juarès, wrote a note to Rodin on behalf of a friend, characterizing him by the title the statue had borne when it was first exhibited, "One of your most fervent admirers, the Portuguese thinker and poet Guerra Junqueiro, has asked for a word of introduction to you. . . . Your recent work has seemed to me beautiful and strong."[20] (The note was dated May 29, sometime after 1904.) Ironically, when François Mitterrand assumed the presidency of France in 1981, one of his first ceremonial acts was to place a rose on the tomb of Jean Juarès in the crypt of the Pantheon, the building where the socialist leader had been buried after his assassination in 1914 and before which *The Thinker* had stood for many years.

Rodin's image of himself as a worker, which was well publicized, and the proposed colossal *Monument to Labor* left no doubt as to Rodin's sympathies, and his statue must have seemed to many, as it appears it did to the artist himself, to have been the culmination of his efforts on behalf of the workers. (Rodin's public testimony against repeal of the child labor laws came from his distress over the potential loss of the apprentice system that he believed was crucial for the development of artists.) To those on the left, the Pantheon seemed the shrine of the heroes of the elite, but Rodin's *Thinker* would enshrine the worker-peasant, the little man. Whether his decision to enlarge the sculpture was influenced by the political and social events of the time we may never know for certain. When he told the reporter that *The Thinker*'s "gesture

could not be that of a provocateur abused by false promises," Rodin must have been guarding against the accusation that his statue was intended to incite further violence at that time.

As a footnote to the drive to separate church and state and reestablish a secular national religion based on events surrounding the French Revolution, an unsigned article appeared in *Le Radical* on June 5, 1905, titled "Civil Festivals, Artists' Projects." It recounted a meeting, held fittingly at the Café de l'Univers, that was called by Rodin's good friend the painter Eugene Carrière to discuss the subject after which the article was titled. As he did not like the July Fourteenth celebrations, Carrière stated the purpose, "It is a question of a purely artistic manifestation. . . . [The celebrations] did not take inspiration from the 1794 Festival of the Federation, that had such a great character. One must give significance to July 14th." The meeting was then taken over by another friend of Rodin, the writer Charles Morice, who was for renewing the Festival of Reason. The occasion of the inauguration of the statue of *The Thinker* by Rodin seemed to him propitious for inaugurating a celebration for "free thought and for which one would create 'des chants de circonstance.' "

The inauguration ceremonies that took place behind the black iron fence before the Pantheon on April 21, 1906 were attended by tophatted dignitaries and many subscribers (fig. 50). One of the principal speakers was, of course, Gabriel Mourey, who essentially repeated his 1904 account of what inspired the project. Specifically, it was the statement made by one of his partners, presumably Gustave Geffroy, upon seeing the sculpture in the Salon:

> From the summit of his *Gates of Hell*, Rodin brought down among us this figure, the first version of which dates from the moment when he began to be conscious of himself. Now, on the threshold of his old age, he recreates it, in amplifying all his experiences as a man and artist. This is no longer the poet suspended on the gulfs of sin and expiation, crushed by pity and frightened by the inflexibility of dogma; this is no longer the exceptional being, the hero. This is our brother in suffering, curiosity, reflection, joy, the eager joy of search and understanding. This is no longer a superman, a predestined one; this is simply a man of all times, of all latitudes, or rather, not of the modern West only, because he does not show himself to be either passive or resigned; he is neither Buddhist nor Christian. From the contemplation of the

world into which he has plunged, he will not awake distrusting life. He will
arise and march. . . . Imagine him standing; the gesture of thought will become
a gesture of work, of fertile energy. *The Thinker* of Rodin is over and above
all a man.

The second principal speaker was not a member of the Paris Municipal
Council, which had rejected the placement of the sculpture siting on city
property, but rather the Under Secretary of State for Fine Arts, Henri Dujardin-
Beaumetz, who had to have recommended that his ministry contribute one
thousand francs to the subscription and approved the site and who later was
to record his conversations with Rodin on art. Mindful of the critical time in
which the ceremony took place, he spoke of Rodin as a "son of the people,"
who had labored long and hard as a *praticien* (technical assistant to other
artists), for many years unrecognized and unjustly treated. He compared the
"unknown" *Thinker* to those unknowns in the tympanum of the Pantheon,
notably the soldiers, who fought for glory and liberty. By implication, the
unknown people commemorated on the sculpture of the Pantheon had been
literally and figuratively marginal in the past, but with *The Thinker*, they were
now central, most important of all, in the mind of the government. Dujardin-
Beaumetz also commended the citizen support that, rather than the will of
the state, was responsible for the sculpture.

> *The Thinker* that today we salute is also an unknown; he is muscular like an
> athlete, vigorous like a clearer of his native soil; he is calm in his strength,
> *because he will only use it in the service of law.* If his attitude betrays some fatigue,
> it is because he remembers perhaps the long centuries of struggle and oppres-
> sion. Thinker to the common soul, he does not forget that it was he, bent to
> the earth, who first seeded and harvested. It is he a hundred years ago who
> made of vengeful iron the tool of liberty. He is the hard-working worker who
> successively made supple and disciplined materials furnished by nature and
> utilized them for social progress. It is he in the end who by work built the
> modern world and wants it worthy of his long efforts.[21] (Emphasis mine.)

50 The dedication of *The Thinker* before the Pantheon in Paris, April 21,
 1906. Rodin is sitting at the lower left.

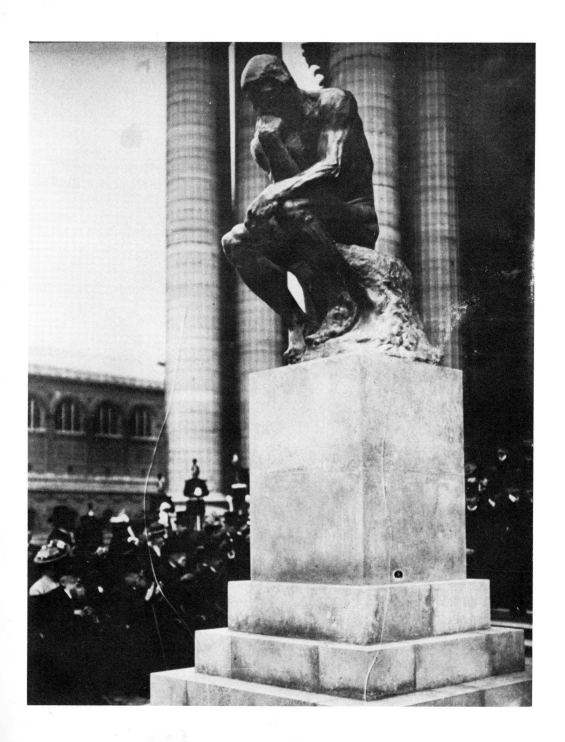

The Dilemmas of Modern Public Sculpture

The critical outcry for and against *The Thinker* and its public installation was not new, but it is recent historically and a model of the dilemmas faced by those living under elected governments who would install modern art in public. No more bitter and successful battle against putting a modern sculpture in an urban space was ever fought by opponents than when Rodin's own *Monument to Balzac* was rejected by its commissioners in 1898.[22] As a young man Rodin witnessed the public outrage against *The Dance*, a sculpture created by his hero at the time, Carpeaux, when it was unveiled on the facade of the Paris Opera in 1869. Before the modern republics, we can look back to the last years of the Republic of Florence, when Michelangelo's statue of *David* was stoned while being transported to its site in front of the Palazzo Vecchio. The act may have been committed by supporters of the Medici, who were critical of the republic, or by those who found the biblical hero's nudity offensive to their sense of religious decorum. Under authoritarian regimes—and this is still true today—there are no public debates about the suitability of locating a statue in public space; but when the regimes are overthrown, so are their statues, as we saw in Prague, Teheran, and Rhodesia in recent times.

When one reads through the articles that recorded the controversy over *The Thinker* from June 1904, when it was first known that it would be displayed in public, through the period of its inauguration and afterwards, it is somewhat like reading arguments in today's newspapers and magazines about public art. What follows is a grouping of the older arguments under headings that are applicable to today's controversies.

Who Decides? or The Few Select For the Many. Unlike the election of public officials, the selection of public sculptures has not been by popular vote. Republican and parliamentary governments have established ministries, agencies, councils, or endowments whose selection of art may, or may not, stem from private or popular initiative. Public initiative played an unusual role in *The Thinker*'s installation. Recall that the decision to promote *The Thinker* for a public site was made by a poet who edited a magazine on the arts, an art critic, and another friend unnamed but presumably a writer. They were not

chosen by the citizens of Paris, but on their own initiative started the campaign for a public subscription, presumably with the artist's knowledge and consent.[23] They formed a committee of celebrities, artists, writers, politicians, and others with known sympathy toward art whose adherence to the fundraising campaign they believed would be helpful. They had problems raising the considerable sum of fifteen thousand francs, but in the end wealthy private citizens and the government stepped in. The campaign also depended upon a number of supportive articles to educate the public into the meaning and importance of the art and to offset the predictable opposition in print. The initiative of a very few who took art seriously and believed sincerely they were acting in the public interest, a fundraising effort, money from the government, and an educational effort in the press should all sound familiar to the reader who follows similar contemporary art campaigns. Public criticism of the sponsors for elitism is also still common. Similar criticism continues to be a symptom of modern society's ambivalence toward experts; in fact, it is a love-hate relationship. The public depends upon experts but is delighted when they are challenged or proved wrong.

Why Public Sculpture? Despite the long tradition of public sculpture in Paris and the artist's fame and established reputation, Rodin's supporters still felt compelled to justify putting modern sculpture in public. They were aware that there was still a strong hostility among certain critics to Rodin and modern sculpture, and they believed they should also address themselves to the education of the public. Upon seeing the statue under the dome of the Grand Palais, the critic Roger Milès wrote, "It seems to me that this austere figure is there . . . in order to invite the sympathetic passerby to the obligations of thinking. There is, therefore, an idea and an act." Senator Edmond Picard, who was a strong supporter of Rodin, wrote an opinion that subsequently has known many paraphrases because it recognizes the unverifiability of any public need for art and its benefits and because the writer has faith that art has the power to contribute to the public welfare.

Will *The Thinker* have a hygienic effect on the noisy crowds around him? Will he purge habitual baseness, miserable thoughts, ordinary filth, wicked hos-

tilities? Who knows! *Let us have confidence in the ameliorating and enobling virtue of Art*. If that will not do any good, it can't do any harm either, as Carmen said to her lovers. It is never unhealthy to believe and it is not prohibited to hope. (Emphasis mine.)

Complementing those who wrote on general purposes, some argued for the good the statue would do for Paris and Parisians, contributing to the people's pride of place and self-image. Edmond Picard continued his article in this vein, referring to Mourey's proposal:

> It is noble to have thought that this magnificent work would do good some-
> where in Paris, the great city, not only for the austere joys of the eyes, but
> above all as proof of the mission of the statue maker, as a lesson and contrast
> in the cosmopolitan tumult, noisy and festive, of a city that seems to function
> only for the pleasures of two hundred thousand strangers who have trans-
> formed it into an inn of snobbism, showy adventures, and all that is monstrous
> and derisively called the great life, the high life . . . let us put it as the dirty
> life. . . . But I am a socialist.

A second elected socialist, Deputy Pierre Baudin, wrote a moving and poetic reflection on the streets of Paris, saying that one cannot be indifferent to the crowds and how the streets have been abused by those in power. He also commented on how artists have a horror of the void and the fact that the city is overcrowded with public statues, socles, bas reliefs, and ugly mon-uments capable of arousing the indignation of the true lovers of art. "The city merits being saved, and even reserving [spaces] for eminent definitive and unquestioned works that can add to its grace, to its life, or to its marvelous ostentation. This is why I accept with joy the idea of M. Gabriel Mourey."

Baudin's argument then encompassed the whole country and offered the proposition that renewed nations have need of fresh self-images in art:

> [*The Thinker*] offers to us the most complete representation and the most living,
> present humanity. . . . He is the one of tomorrow. Michelangelo erected the
> synthetic image of the aristocratic and violent society of Italy in the figure of
> a Medici. . . . *Liberated and reformed France has the right of a new symbol*. This is

not the placid and resigned thinker, ashamed of crimes that have afflicted his life or country. This is not the thinker sheltered in meditation and dreaming near his weapons of a pacified and reasonable time. But it is a man, neither prince nor lord, nor dominator, nor bourgeois. It is a man equivalent to that unknown laborer who in recent centuries puts himself under the obligation to reflect on the complex forces to which all effort must respond. . . . He illustrates no name, he gives no assurance of fame, he is the anonymous creator who must confront the complex duties of social life. (Emphasis mine.)

In sum, *The Thinker*'s advocates believed he was ethically inspiring and would improve the public's mentality; the statue would provide a new and welcome self-image for the people and for the city in which it stood, as well as for the nation. Although it was undoubtedly in the hearts of Rodin's supporters, not until the time of the inauguration was the argument made openly of honoring the artist and the work of art. Dujardin-Beaumetz spoke of how all involved had "chosen to honor a great artist." During the subscription campaign, Rodin's supporters may have felt the climate was politically and socially unfavorable to honoring individuals, rather than a broad symbol of humanity or the working class. With few exceptions, Rodin's supporters did not make the obvious argument that *The Thinker* would elevate public taste by adding beauty to the urban environment. This was Pierre Baudin's case.

Here is the great lesson of beauty that this statue of Man must one day make understood to the people. This animated material is in itself proof of human power. The statue will uplift the crowd from which genius is born. It can be measureless in the faith it can inspire, the pride it makes accessible to the humble. . . . [among] the great symbols of life, the creatures of art alone have the indefectible character of beauty that accords with the constant and superior conception of life. *The Thinker*, bending over the multitude, will be the respected image of the human form of eternal will.

At the inauguration, Dujardin-Beaumetz openly praised Rodin's work for joining the grandeur of the idea and beauty of form in a clearly comprehensible way. Even from so important a source, these views did not quiet or satisfy the sculpture's critics any more than support from the National Endowment

for the Arts today guarantees a public sculpture immunity from adverse criticism.

All Rodin's admirers seem to have concluded that they should stress what the sculpture represented and its contribution to the elevation of the public mentality and spirit. While it may seem to us today that Rodin might not have welcomed the heavy moral burden placed on his sculpture, in fact he was in favor of the traditional purposes of public sculpture: to educate, elevate, and delight.[24] He may have disagreed with the conservatives on how to accomplish these ends, but he believed that public sculpture had a noble mission. Rodin's dilemma, however, was that of the modern sculptor whose art derives from deeply held personal values, which often conflict with those of the public that the artist chooses not to celebrate. Transforming inert materials into art, the modern sculptor, beginning with Rodin, *enacts* rather than depicts values important to healthy societies, such as making disciplined and constructive use of his or her artistic freedom. In the immortal words of Stephen E. Weil, Deputy Director of the Hirshhorn Museum and Sculpture Garden, "Nobody gotta have art!" Modern sculptors, starting with Rodin, who want their work in urban spaces have been challenged to educate the public and critics in their personal value systems and to create, at the minimum, tolerance for their beliefs.

In Rodin's day, a successful sculptor brought glory first to his country and then to his profession. France was proud that its world reputation in the visual arts was supreme. Until the end of World War II, the United States was in many respects a cultural colony of Europe and an art-importing nation. During the 1960s under presidents Kennedy and Johnson, Americans came to feel that this image should change, that the world should recognize we had developed a culture worthy of recognition and export. Those who complain today that the government has no business using taxpayers' money to fund public art, because most of the public does not appreciate it, should read the 1965 act which established the National Foundation on the Arts and Humanities. The act does not specify what proportion of the public must be satisfied with government-sponsored outdoor art. Instead, the relevant portions of the Act read as follows:

(5) the practice of art . . . requires constant dedication and devotion. . . . while no government can call a great artist or scholar into existence, it is necessary and appropriate for the Federal Government to help create and sustain not only a climate encouraging freedom of thought, imagination and inquiry but also the material conditions facilitating the release of creative talent; (6) . . . the world leadership which has come to the United States cannot rest solely upon superior power, wealth and technology, but must be solidly founded upon worldwide respect and admiration for the Nation's highest qualities as a leader in the realm of ideas and of the spirit.[25]

Thus, while claiming to have wrested cultural leadership from the Old World, the United States government was taking a lesson from countries such as France in supporting the arts partly for international prestige.

Is This Public Sculpture Necessary? or Who Needs It? The critics of the proposed public sculpture were no more elected by the people than were its advocates, but they claimed to speak for the masses. Some may strike us as pseudo-populists. Like some of today's philistines, the adversaries of *The Thinker* claimed to support the traditional purposes of public art and to honor collective values, heroes, and heroic achievements. When they began to work against Rodin's sculpture, critics like Jules Harmant did not hesitate to attack the "sincere admiring elite and museum habitués" who were sponsoring it for ignoring the true needs of the people. None was more caustic than Harmant:

The committee in question proposes to offer this singular Thinker to the people . . . Art for the People, Beauty for the People, all in capital letters. This is one of the good jokes. . . . The people have need of air and light much more than of statues and, in fact, Beauty. They would truly be happy with more healthy lodgings than those they now actually stagnate in. *The Thinker* of Rodin will not change anything in the black Faubourg [the quarter in which the Pantheon is located], and he will have only one excuse, that of surrounding himself with a square where one will not see him too much and where he will be permitted to breathe.

Although probably not the first to use it, Harmant's ploy is by now a classic: *create a false choice*, offer the public the illusion that if it wasn't for the work of art, the people would have better living conditions, as if the necessary amount of money actually existed to finance either but not both choices.[26] Then and now, critics who plead social responsibility before art seldom carry their cause outside of the art world and dedicate themselves to improving public housing.

A corollary to the argument, one still advanced by the more prudent philistine, is that we have enough art already. A writer with the initials A. M. described *The Thinker* in the May 1904 issue of *L'Action Littéraire et Artistique* as "a defeated athlete who bites his fist, his Adam after the fall. . . . But after all, why another nude man in some square?" (Today one could substitute "abstract sculpture" for "nude man.") The difference between A. M. and Pierre Baudin is that the latter was critical of most public art, but came out for high standards and cited his model.

Whether under the republics of ancient Greece and those founded during the Middle Ages there were taxpayer complaints about the use of taxes for public sculpture does not so far show on the record with questionable exceptions. According to Plutarch, Pericles' political enemies took him to task for using funds raised for war against the Persians to give Athens a "fair face" that included considerable financial expenditures for Phidias' statue of *Athena Parthenos*. (Recent scholarship has questioned whether Plutarch was accurate in ascribing these criticisms to Pericles' contemporaries.)[27] In the twelfth century Saint Bernard of Clairvaux took Abbot Suger of Saint Denis to task for clothing his church in gold and the faithful in rags. Some Florentine taxpayers may have muttered under their breath when Michelangelo's *David* was installed. With the advent of newspapers, it was easier for unhappy taxpayers to record their objections for posterity. Shortly after the bronze-painted plaster of *The Thinker* was set up before the Pantheon, an unsigned article appeared in *La Liberté* on November 30, 1904: "*The Thinker* of Rodin has been set up yesterday before the Pantheon. It is only a study. . . . let us hope it will not succeed because this Thinker is a grotesque thing. One truly does not have the right to inflict on us who pay our taxes this lamentable mystification. *The Thinker* of Rodin will soon disappear, it is to be hoped."

This outraged taxpayer raises the question of the possible damage that modern public sculpture can cause, contrary to the view of Picard, who believed that if it did not do good, it would not do harm. Sculpture is reckoned offensive to the intelligence of the public, which resents being mystified, as well as harmful to its aesthetic sensibility.[28] Inevitably, those who feel mystified by public sculptures question the artists' sincerity and the seriousness of their intentions. The irony in the criticism of mystification is that Rodin's statue, like so many modern sculptures, was stripped of symbols and was intended to be self-evident and even open-ended in its meaning. Unlike Renaissance art, *The Thinker*'s meaning did not require an education in the esoteric for comprehension or interpretation. If anything, in the context of its time the sculpture was anti-intellectual in meaning and anti-elitist in form. This is a historical change that even today the public cannot get used to or else finds difficult to accept. It is as if the public must have the artist's intention certified, perhaps in a sworn affidavit inscribed on the base of the sculpture, where before they found legends describing famous people. The public seems to enjoy taking risks on many things, from lotteries to sports to politics, but not art. Another public reaction is impatience with the time it may take to develop a familiarity with the work, a familiarity that breeds not contempt, but understanding. Immediate explanation, such as that found in photo captions, meets the public's demand for instant gratification. Not surprisingly, one of the dilemmas of modern sculpture that has remained consistent is that it disappoints the public and certain critics for having *less* than they expected: less meaning, less skill, less beauty, and so on. "Less is more" may have inspired modern architects and artists but often it has not gone down well with the public.[29] Rodin was not the last modern sculptor to credit the public with more sophistication than it knew it had, nor the last to experience the reaction that he was making fun of his audience.

Why Choose a Famous Artist? In the past, cities such as Florence took pride in having the work of famous artists, preferably native sons, in their public spaces. Although the artist might be admired for his skill, in ancient times the subject of the sculpture, rather than the sculptor, was held up for emulation by fathers to their sons. In medieval Florence and in the case of Giotto,

we see the beginnings of a reversal of this value system, and civic pride was augmented by association with a great artist. By the time of the Renaissance distinguished artists actually began to pressure their cities to install their work in public. In the twentieth century, however, there appears the concern about neglecting younger artists in favor of famous elders. It has been a good ploy for critics of famous sculptors because it wins the public's natural sympathy for the "starving" but deserving artist. Usually these critics have been careful not to name their unknown candidates, thereby evading a controversy over their own selection. Ironically, Rodin's own history of critical and official neglect may have contributed to this attitude, but he in turn became a victim of the appeal to give a younger, unknown artist a chance. Early in the sub-scription campaign for *The Thinker*, L. Augé de Lassus argued in his article, "The Two Thinkers, Michelangelo and Rodin": "Without going out of our art palaces, it would be easy enough to discover statues signed by unknown names and which are well worth this famous thinker. How many artists wait vainly for the reputation that is their due. . . . Rodin does not wait for anything. He has obtained all that is his due . . . will he not disappear under his laurels and the fall of laudatory leaves?"

 This is the beginning of the modern story of the great artist who is the victim of his own success and has lived too long for certain critics. In our own time Henry Moore and Alexander Calder are prime examples of senior artists who lived long enough to see their work all over the world, where countless communities have taken pride in owning their work and showing it in public, but who also read complaints that it was banal or even cowardly to select them and detrimental to the encouragement of younger talent. That Rodin, Calder, and Moore went half of their lives without major public commissions, and that large segments of the public take pleasure in experiencing their art, is either forgotten or dismissed in arguments such as that of de Lassus: they've had their due; now it is time for someone younger. A quandary that may prove eternal for those who favor public sculpture is that there are never enough experienced sculptors of high quality to supply the demand for out-door art. In Rodin's day as in ours, there were thousands of sculptors with talent, but few with genius, certainly in insufficient numbers to give public art an unassailable reputation. Artists are entitled to reply that there has

always been a shortage of great sponsors, people with access to the necessary funding coupled with knowledge, taste, courage, and stamina. Once again the problems reduce to less, or not enough.

Why This Site? or Public Art Is Fine, but Not in Front of My Building. Rarely do communities, including universities, provide for public sculpture in their planning. The idea of installing modern sculpture in the out-of-doors is almost always a second thought, an intrusion. The site and the sculpture's relation to it are the results of compromise and are rarely satisfactory from everyone's viewpoint. There are always members of the community who say that in principle they favor public art, but when the proposed site is in front of their building or in their neighborhood or near their favorite civic structure, they have reservations. Private proponents of public sculpture are often naive about the politics of siting outdoor art and may be disillusioned with the inevitable compromise. From the artist's standpoint, it is ideal when he is given a site of which he approves and for which he can conceive his sculpture. The case of *The Thinker* is more typical, however, the problem being to accommodate a completed work, one originally conceived on a smaller scale for a totally different context. Whether or not the modern sculptor has an initial context in mind, once his work is proposed for a particular site, it usually leads an entirely different and unpredictable life, a situation that pleases some sculptors and dismays others.

The dream of Mourey and his associates was for the statue to go in the center of Paris, "in the heart of the crowd, among the rumblings of daily life, among the clamor, the fevers, the agitations of the street." For these writers the contrast of thoughtful stillness amidst the tumult would be salutary and uplifting. The suggestion of placing *The Thinker* before the Paris Stock Exchange, however, raised the spectre of a site that would invite ridicule of the work of art, as well as of a famous institution. Figural, rather than abstract, sculpture may be more prone to such situations, as it is instinctive in all of us to make associations and puns.

Edmond Picard worried about the siting of Rodin's sculpture in his article published in the Brussels periodical *Le Peuple*:

Where will this troubling masterpiece be set up? In what corner of Paris, where so many statues irritate the eyes and provoke devastating reprisals of a rational iconoclast, as if in order to cause riots one must count on pretexts other than political ones? It seems the site for *The Thinker* should be a mysterious corner, a sort of secret chapel, a sanctuary in the middle of the noisy hubbub of the city. Probably, with the customary tact of the directors of Public Art, they will erect it on a square sufficiently enormous to annihilate his harmonious proportions. Were not *The Burghers of Calais* placed between a post office and a public toilet?

One of *The Thinker*'s opponents, Jules Harmant, was very clever in making an argument that at first did not seem to be against the sculpture itself, but appeared to praise it. He then used a smaller work by Rodin, *Thought*, (fig. 51) on a similar theme that was intended, however, for intimate or indoor viewing, such as in the museum where it was located, and he ascribed its qualities to the bigger outdoor piece. Having tried this sleight of hand, he then claimed that a public site in a crowded portion of the city was wrong for the qualities *The Thinker* supposedly presented. In "La Sculpture de Rodin," Harmant gives a good synopsis of the character of customary public sculpture:

[I]t is for the crowd that this statue will be installed in the open air. Now, what attracts the attention of the distracted or busy passerby is in general not that which comes from the ordinary, but that which is colossal or theatrical: the more or less fantastic reproduction and embellishment of a great historical scene, the bust or statue of a great man whose memory and features are idealized, or again a group of personages with great proportions and extraordinary attitudes. It is not a question of bad taste, but one of optics—there is a visual question.

With the art of Rodin we are far from all that. Like all artists of genius he has wanted to express life itself, but life that is the most internal, which rises from the depths of our being to be reflected on our face and in our physical attitude.

[Harmant analyzes Rodin's marble sculpture of a woman's head resting atop a roughed-out cube of marble, titled *Thought*, and singles out the mysterious expression of the human personality by means of the physical person down to the last details.]

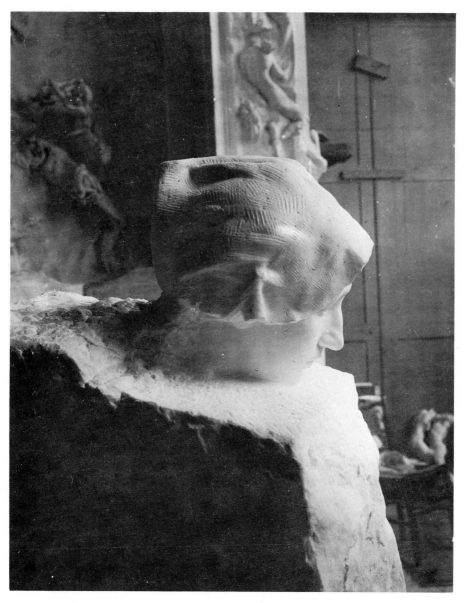

51 Rodin, *Thought*, marble, 1886, photographed in Rodin's studio in 1900 with *The Gates of Hell* in the background.

If that is the intention of the artist, such should be the spirit in which his work must be admired. Because he has wanted to express life, one must place oneself before his statue with the welcome and the respect that one owes to life. Now, for such a respectful welcome the tumult of the street would not be suitable.

After such a reasoned and seemingly sensitive reading in which he has said that the statue is both too ordinary and too subtle, Harmant tips his hand as to why he really dislikes *The Thinker*: "It is not from muscle that thought issues, and this Thinker proves that well!"

Who first suggested the site before the Pantheon and how it was chosen is not entirely clear. In his speech, Dujardin-Beaumetz said that "the Government of the Republic" made the final decision, but probably the government merely approved what others had suggested. In his article that appeared in *Les Amis de Paris*, Léon Maillard wrote:

> For a cause that is unknown to me, the Municipal Council of the City of Paris has always regarded the name and work of Auguste Rodin with complete horror. . . . *The Thinker* was cast. The City of Paris refused a location on which to erect this memorable bronze. Thanks to Gustave Geffroy, and perhaps to Georges Clemenceau, [the Department of] Historical Monuments was more charitable and accorded a fraction of ground before the steps of the Pantheon, behind the grill, ground that did not belong to the City of Paris.

How much Rodin had to say initially about choosing the site is not sure, but he certainly approved it. In the December 1904 issue of *Les Arts de la Vie*, Gabriel Mourey stated, "Rodin himself chose the place." On December 30, 1904, an unsigned note appeared in *L'Univers et le Monde* reporting that the work had been tried in front of the Pantheon in plaster and pronounced satisfactory by the building's architect and Rodin. Even with agreement among the different parties about the principle of locating *The Thinker* before the Pantheon, there had to be a compromise that removed the statue from the Place de Médicis and pushed it back near the steps of the shrine.

Before that final decision, the artist and his supporters were confronted

with the issue of how to orient the sculpture in relation to the building. The work had literally a front and a back, aspects endowed with diametrically opposed connotations, and a pose that would provoke criticism of the orientation no matter what choice was made. When he thought it might be possible to locate the sculpture away from the building on the Place de Médicis, it seems that Rodin considered having his statue face the Pantheon, rather than sit with his back towards it with the accompanying implications that the artist and his surrogate were rejecting what the institution represented. Marcel Adam, interviewing Rodin, wrote, "His ambition is to see *The Thinker* facing the Pantheon, at the end of the rue Soufflot, at the intersection of the Place de Médicis." In this orientation, *The Thinker* might have been seen as brooding on the past heroes of France and their accomplishments, which might have pleased conservatives, or as questioning their selection, which would have delighted the advocates of social change. As Adam stated, "It would seem to meditate on the injustices of the mother country—only recognizing her great men after they were dead." Although he would have been the first to be aware of it, others may have pointed out to Rodin that thus sited, *The Thinker* would have indecorously presented his back to those approaching the Pantheon on the rue Soufflot, and that from a distance this orientation would not be as effective as the frontal one. The decision to place the statue behind the grill, a position which left little space to see it from the building, made the figure's final orientation automatic.

It's Too Small. Henry Moore once observed to the author that all modern sculptures in front of buildings that are more than two stories high look too small. Rodin could improve the relationship of his sculpture to the Pantheon only by putting it on as tall a pedestal as possible. An old photograph taken from a block away on the rue Soufflot shows us how tiny the massive form of *The Thinker* looked when installed before the building (fig. 52). Criticism does not seem to have been published on this subject, probably because, as Moore observed, buildings customarily dwarf sculptures put in front of them. Michelangelo's *David* was made three times life-size and was intended to go on one of the buttresses of the Cathedral of Florence. When the work was

placed before the Palazzo Vecchio with its great tower, prophets of modern criticism may have faulted Michelangelo for making his work too small. When we look back at exceptions, such as can be found in ancient Egypt, Greece, and Rome, and in Europe under kings and emperors and modern dictatorships, larger than life-size public figure sculptures have been associated with authoritarian institutions. Since World War II, Americans, for example, are uneasy about putting life-size statues on pedestals and seem comfortable only with gigantic figures in the form of balloons in the Macy's Thanksgiving Day parade. Even the new larger-than-life statue of John Wayne at the Orange County California Airport lacks a tall pedestal.

To sculptors, size is the actual physical dimension of a work; scale is its "spiritual" size. When artists say a work has scale or holds its scale, they mean in the first instance that the work has a potential for monumentality or a certain "largeness of effect," and in the second that it does not look smaller than it actually is. Even sculptures that are large and hold their scale can seem defeated when seen from a distance juxtaposed against a tall building. The practice of evaluating this sculpture–building juxtaposition in terms of scale relationships is a largely modern phenomenon resulting from the interest of painters and sculptors, since at least Matisse, in the effect of the whole composition.

The commitment of modern cities to tall buildings is a problem for sculptors. Those who often find themselves in such situations, including Rodin, take comfort in the fact that from many views closer to the work, where one cannot see the whole building, the form works both by itself and in contrast to the adjacent portion of the building. That is why artists frequently try to position their works as far away from a big structure as possible. Rodin was no exception.

On the other hand, it should be pointed out that the viewer rarely takes in this juxtaposition from one distant, fixed point. Public sculpture is for a mobile audience. As one approaches the building or walks past it, the sculpture–architecture scale relationships change dramatically and often for the better from the sculptor's viewpoint. A viewer leaving the Pantheon can see the sculpture against the sky or more distant and hence smaller backgrounds.

52 *The Thinker* installed before the Pantheon.

Gigantic sculptures that would harmonize with a building from a distance might not work or might be incomprehensible or intimidating to pedestrians from close up.

If a particularly fine public sculpture is placed in an unfortunate setting, in time we tend to screen out what distracts from the pleasure of the experience. Critics today generally seem more forgiving of architects than sculptors for being less than perfect. (How often a good public sculpture has deflected attention from a bigger building that is bad. Providing such an ameliorating distraction may be one of contemporary sculpture's unsung missions.) Fine sculptures that are small relative to large buildings nearby are always gifts to the street, but are too often derided in our addiction to bigness. Such sculptures restore a human scale to our built environment and often supply needed animation and beauty.

What Does It Mean? More than aesthetics, it is the question of a public sculpture's meaning that constitutes one of the greatest dilemmas of modern public art. The inscription on the pedestal of the traditional public monument immediately answers the question of whom the statue represents, usually why he was memorialized, and often by whom. But the inscription on Rodin's pedestal identifies the figure simply as "Le Penseur." Rodin's supporters undoubtedly knew that the public would ask, "Which thinker, and what is he thinking about?" Some of the artist's friends and sympathizers sought to interpret Rodin's figure in general terms, looking to its relevance for future generations, while others saw the sculpture's meaning in terms of contemporary social and political contexts. In the sympathetic interpretations we again encounter views on the mission, as it was termed, of public sculpture. Here are some of the long- and short-term strategies the advocates employed. The first is unsigned, and the writer in an almost poetic way sees *The Thinker* as Rodin's *praticien* (or assistant) or that it is the artist himself who is a worker, and the sculpture "is a worker dreaming of his meager salary, or of the difficulties of life." He goes on to say that "the knotted body and face of the dreamer was discovered in the studio and raised to the level of a symbol." After this poetic prelude, the writer shifts into higher political and social gears.

Democracy has had its heroes and its statues. But these heroes were often no more than bourgeois. Not a single true child of the people had an image on one of our squares without the benefit of a legend or the history of an heroic action . . . Spartacus or Danton, Harmodious or Gambetta, Dolet or Armand Carrel: lawyers and Romans! Our city halls swarm with busts of Marianne . . . but this art counts for little.

The Thinker of Mr. Rodin is, on the contrary, the anonymous unknown worker, the first to come from among the proletariat, whose native homeliness the artist has exaggerated, again according to the exigencies and manner of his art. He symbolizes egalitarian society and the entire Republic.

This apotheosis of the sovereign people in the domain of the fine arts must not be pleasing to our masters. The proletariat will be flattered . . . to see itself endowed with thought—the proletariat that is so often accused of having only blindness and instincts.

His Thinker is crushed and somber. Crushed without doubt by physical fatigue, by the eternal burden and eternal labor; but also crushed by lassitude and moral anguish. And it is by these traits that posterity will recognize the master's genius.[30]

More sophisticated, as befitting a Socialist Deputy, but no less oriented towards the common man, was Pierre Baudin's reading of *The Thinker*:

He is not the intellectual impoverished by an exhausted heredity . . . who has no more guide than reason. This is a strong man, muscled, balanced and calm, who is afraid neither of solitude nor of his annihilation. He measures the value of victory won by all the long past of pain, of anguish, of misery, of joys and grandeurs, of which he must enlarge the conquest.

But he also teaches to workers, to those of the atelier, the earth, the mine, to all, that no effort is worthy of more attention nor of more resources than that of thought. . . . He thinks to be resolved, to will and to act. Soon, almost immediately, he will apply himself. . . . After the thought, work.

A second interpretation, one less politically and socially charged, was also advanced by friends and foes—*The Thinker* was seen as representing prehistoric man. Two of Rodin's most influential friends were writers Roger Marx

and Octave Mirbeau, who knew *The Thinker* almost from the time of its origin in 1880, when, partly because of Darwin, atavistic themes were popular in sculpture and such titles as *The Age of Bronze* were not uncommon.

> I have been repeatedly asked why Rodin has selected for his thinker a hang-man, or something of the type. Such a person, they say, is surely more like an animal than a human being. And they never suspect how near they were to the truth. . . . Rodin wished to create the original thinker, the thinker who enabled man to rise above the animal, the first animal inspired by the spark of divine wisdom, who struggles with convulsive pain to give birth to the first thought. It is this prehistoric man, the first, the greatest of all men, whom Rodin wished to immortalize in his statue.[31]

> *The Thinker* . . . with his worn body and face of a primitive man, the image of a cave man, is the prognathian looking at the unfolding below of the crimes and passions of his descendants. *The Thinker* in his austere nudity, in his pensive force, is at the same time a wild Adam, implacable Dante, and merciful Virgil . . . but he is above all The Ancestor, the first man, naive and without conscience, bending over that which he will engender.[32]

The association of the statue with early man did not always redound to the art's favor. In 1908, an indignant Paris Municipal Councilman attacked it by claiming, "The most mediocre student in our beginning drawing classes would blush to present such a sketch, but when the author of a pithecan-thropus dishonors the portico of the Pantheon, they do not hesitate again to dupe the public."[33]

Explaining to the public the meaning of a proposed sculpture is another no-win situation. Its advocates are damned as snobs if it is not explained, and the work is damned if it is, because the dissenters argue that any "true" work of public art should be self-explanatory. Such was the case with *The Thinker*, and the point was made by a writer with the initials A. M. in a 1904 edition of *L'Idée Libre*: "Without a doubt, when one has imagination and a refined artistic education, one can see many things in a work of art; one can even finish by finding that it expresses the idea inscribed by the author below

[presumably in the title or legend]. But a true work of art does not have need of an explanatory label; it must speak for itself."

This is the same writer who believed that *The Thinker* was a beaten athlete who bites his fist and should not be in a public place.

In Rodin's time it had not yet become the custom to seek out the artist and then print his own interpretation of his work widely. Writers, especially critics, presumed that it was their function and prerogative to interpret art for the public. It many ways it was their justification for being. This practice may explain why there is relatively little commentary by Rodin on *The Thinker* and why his supporters did not usually quote him. Rodin was neither the first nor last artist who, when asked, was often reluctant to verbalize his intentions.

The Dilemmas of Decorum and Taste. During Rodin's lifetime many critics and presumably much of the public still looked to public figural art as a model for ethical conduct and even physical deportment. Paul Dubois's *Military Courage* provided such a paradigm (fig. 53). The military liked artists to fashion bodies that seemed formed by rigorous physical training, and the government and intellectuals wanted the figures to have the look of intelligence, reflecting a sound education. Good posture, mental alertness with no lassitude, and graceful or vigorous and decisive movement were all considered desirable. Critics looked further, however, to see if the form of the work was adequate to the theme and if the figural type used was appropriate to the subject. If the subject was noble, its embodiment should be suitably dignified. That is what decorum was all about and what students in the official art schools like the Ecole des Beaux Arts were indoctrinated to believe. The Ecole realized that not all public sculpture should be beautiful and recognized a category, ranking below the beautiful and noble, that was called *the expressive*. This term meant that, especially in relief, themes calling for the action of many figures might not allow or call for beauty. For conservatives, however, the "noble" theme of *The Thinker*, precluded protection of the sculpture by this classification.

After 1877, Rodin rejected academic notions of beauty, which he felt were a betrayal of nature and ancient Greek art. He protested against the frozen

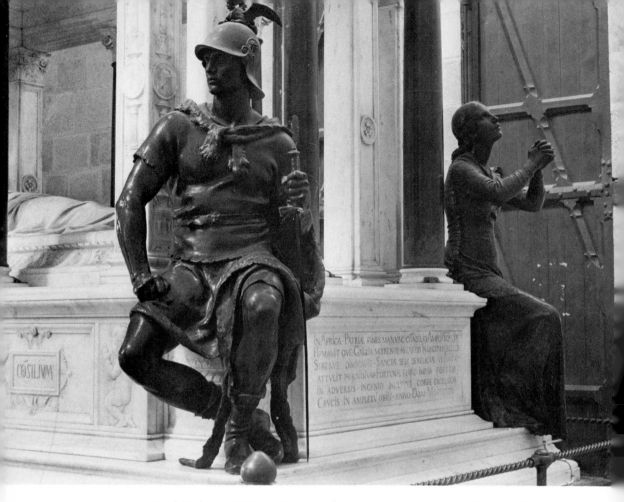

53 Paul Dubois, *Military Courage*, from the monument to General La-moricière, Nantes Cathedral, 1876.

and false neo-Greek nobility that contemporary monuments aspired to. No view set him more apart from academics than his insistence that nothing in nature was ugly, and for him there was only bad sculpture. Anticipating Picasso, Rodin thought artists should be free from the limitations of categories established long ago by others, and he did not restrict himself to the self-conscious search for beauty. Both men sought a personal view of artistic truth.

Their legacy has been potent, and rare is the modern sculpture offered for a public site whose supporters claim that above all it is beautiful. They know they will be immediately challenged to define beauty, on the one hand, and on the other, the artist may have been interested in other things.

For modern sculptors to say that a given work has good form implies that it has aesthetic value or beauty of some sort. Modernism did not reject beauty, just the dogma of an impersonal, absolute, or true beauty. Modern sculptors avoided the exclusive or conscious pursuit of beauty as an end in itself. They relativize it, often giving it a supporting rather than leading role. Those like Rodin who were on the cutting edge of this change suffered the critical consequences. Rare are the negative reviews of contemporary public sculpture that can match some of those addressed to Rodin and *The Thinker*.

> Rodin is superior in inferior subjects and powerless with elevated subjects. The study of *The Thinker* will show this clearly. . . . The form is antithetic to the theme. This Thinker is the Dante. Even if one faults this idea, it is evident that the faculty of thought will translate itself by movement, and will burst out from the plastic character. At the same time that the subject elevates us, the form must underline and repeat this elevation, that is, be beautiful. . . . This bronze does not realize the idea proposed; it parodies it, and more, it lowers sensibility by imposing a hideous and vulgar spectacle. . . . M. Rodin diminishes rather than increases our conception of beauty.[34]

In an unsigned article titled "Le Penseur de M. Rodin," printed in the December 8, 1904 issue of *Le Chroniquer de Paris*, Rodin received another blast. The correspondent credited him with "virtuosity and facility," but went on to say that in the future he would be recognized as "a superior technician." This article is also a rare critical example in which Rodin was faulted for relying upon the interaction of light with his surfaces, in fact one of his greatest artistic strengths. Conservatives believed that the form should be conceived and realized independently of any luminous effects.

> But M. Rodin lacks the two faculties that constitute great artists: he does not see plastic beauty; he does not understand the decorum that must exist between form and ideas. . . . *The Thinker* offers all the physiognomic and physical

traits that are antithetical to the idea of thought. It is the body of a stevedore, in a pose of lassitude, of physical constriction; the head is without a brain, the muscles are those of a primitive man. All the forms awaken ideas contrary to those of thought; ideas of material work, of brutality, of sorrow. The pose . . . seen in a certain light, [can] express meditation, [but] is contradicted by the importance of the body, and in sculpture it is an error to find expression by luminous artifices. Here, as elsewhere, M. Rodin, incapable of that sobriety which is the sign of power, makes a caricature. . . . A work of art is beautiful when the forms are harmonious and correspond to the proposed theme.

The Vulnerability of Modern Public Sculpture. The anonymous writer of an article on *The Thinker* in the December 30, 1904 issue of *L'Univers et le Monde* was very prophetic when he warned that the apotheosis of the worker by means of this sculpture "unknowingly or involuntarily lends itself to a satire or sarcasm." He added, "Rodin sought to mock the masters of the time and this exaggerated his defiance and irony—how often an artist's work achieves that which was not in his head." Almost any modern sculptor who has placed a figural or abstract work in public can testify to the truth of this last sentence.

Rodin knew personal attacks—an unsigned May 1909 article in the *Chronique d'Art* called him a "madman—*The Kiss* and *Balzac* are evidence of total derangement." There is no evidence that he used the press to fight back, but he must have been touched by the severity of the verbal assaults on major works like *The Thinker*, which ranged from the foolish to the vulgar. "This coarse man seems to be a malcontent who ruminates in anger rather than a sage. . . . I am not tempted to ask him his secret as he seems more menacing than attractive in his silence."[35] Another states, "Go before this thinker, and first look at the face: it is a brute, a sort of gorilla; he will represent a worker in all that is vile and gross; this could be an effigy of Caliban."[36] The worst criticism read, "To rest a head heavy with creation on a fist is a symbol like those of the Epinal School [popular prints made in Epinal for the uneducated]. . . . One must have the aesthetic culture of an Aurignacian or find oneself under the influence of several bottles of whiskey in order to accept the symbol of Thought in this attitude of a constipated man exerting himself on a chamber pot."[37]

One of the worst things a critic can do to an artist and to the public is to refuse to resist the temptation to exercise his wit at the art's expense and to caption a sculpture facetiously, "brute," "gorilla," "brute on a chamber pot," and so forth. This type of critic knows the public loves clever captions, for once the art is verbally encapsulated there is no longer any need to think about or look at it, at least in an unprejudiced way—and it is much more fun to talk about. Rodin knew that along with the "effets de pigeon" his *Thinker* would be comparably decorated by shallow critics. But the work survives both, and its message to viewers to think for themselves remains silently eloquent.

We have already seen how vulnerable Rodin's plaster cast of *The Thinker* was to the axe of a madman. In 1970 the lower portion of the bronze cast in front of the Cleveland Museum of Art was blown apart with plastique by a person or persons who were never caught (fig. 54). The reaction of the public and critics toward such acts of vandalism is not always horror, anger, or even dismay. There are those self-described philistines in our culture who vow they are acting in the public interest who dignify vandals of art by describing them as "aesthetic avengers" or "aethetic vigilantes," crediting them with possibly having some community support; they show no sign of being personally disturbed by such criminal acts.[38] In Rodin's day at least one writer was delighted to display his mixed feelings about Poitron's act of vandalism. In the January 19, 1905 issue of *Le Chroniquer de Paris*, Henri Perrin wrote a short piece titled "Under the Hatchet":

> Savage and brutal, such is the title of the first novel of Elémir Bourges. . . . such has also been the end of Rodin's *The Thinker* in plaster placed before the Pantheon, in the period of waiting for the bronze—deterrent to all hatchets. . . . Here at last completes the glory of the Michelangelo of the gorillas. . . . Sick or crazy, a chauffeur, he says, broke the maquette with blows of a hatchet the other night. Fortunately this was only a plaster, and the malefactor had only a plaster brain! If not, if he would have made some theory, some aesthetic explanation, for the origin of his gesture; Rodin would have become a hero, the hero of new art, prehistoric art. But the adventure teaches how exposed are works of art to all madness.

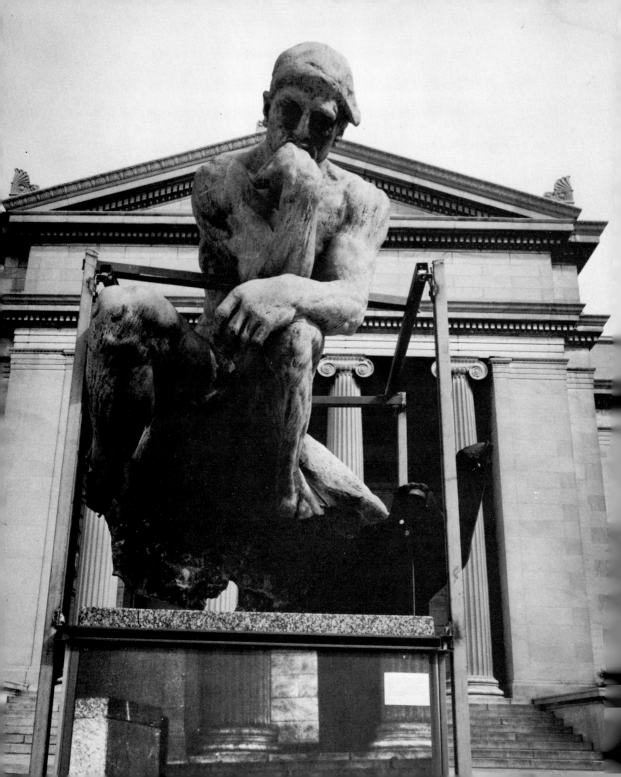

Even Perrin commented on the madness in Paris of placing guards in front of official entrances or offices, but leaving "the treasures of humanity" unprotected. It is ultimately the maturity of the community that lives with the work and the dignity or beauty of the work itself that are its only protections.

In the doublespeak of the art world, to install a public sculpture permanently on a site does not mean that it is there forever. Vengeance succeeds when vigilance sleeps. Again, *The Thinker* is a model case history. Its inauguration before the Pantheon on April 21, 1906 must have seemed a triumph to the artist and his supporters. To be sure, the statue remained in front of this celebrated building for sixteen years, but in 1922, by order of the Ministry of Public Instruction, it was quietly removed and installed in the Musée Rodin.[39] There was no great outcry in the press to defend the artist, who had died in 1917, or his work. In June 1923, in his "Notes on Rodin," Léon Maillard wrote, "The struggle undertaken against Rodin by the city of Paris has had its logical ending . . . it had obtained from the State its consent that the monument would disappear."

Many years after Maillard's brief account, Judith Cladel lamented "the loss to the man on the street of a work that would have influenced his taste and mentality." She wrote, "In 1922, under the pretext that this mass disturbed the deployment of official ceremonies, *The Thinker* was sent back to the Hotel Biron and placed in the Court of Honor."[40]

Because of its ubiquity, the record of *The Thinker*'s longevity as a public sculpture persists. In many countries it continues to be seen on university campuses or outside art museums. (It also stands inside a bank in Denver and in the Laeken cemetery in Belgium.) Even the damaged cast before the Cleveland Museum was reinstalled without restoration as a reminder of public art's vulnerability.[41]

54 *The Thinker* in front of the Cleveland Museum of Art. The statue was vandalized in 1970 and reinstalled without restoration. Note the metal frame used to support the statue, whose base was shattered.

Rodin, Rose, and "The Thinker"

When Rodin's wife, Rose, died in February 1917, he arranged for her to be buried on their property at Meudon in front of the ruined façade of an old chateau, which he had purchased in order to preserve. Rodin also gave instructions that he was to be buried next to his companion of over fifty years. The sculptor ordered that a cast of *The Thinker* be placed on Rose's grave.[42] This was done by the following September. For many reasons this was a fitting gesture. Rose had been one of Rodin's finest and most inspiring models during the crucial years of his career. When the first version of *The Thinker* was being made in 1880, in all probability it was Rose who wrapped damp cloths around the clay form to keep it pliable between working sessions. After Rose no longer served him as a model, she was still Rodin's most trusted assistant in this delicate work and cared for many of his most important sculptures in this manner for most of her life. After his death on November 17, 1917, as he had requested, Rodin was buried alongside Rose beneath *The Thinker*.

Although not all of the public sites for *The Thinker* have been seen by the author, it seems unlikely that there is a more beautiful and poetic placement of this sculpture than at Meudon (fig.55). The artist chose a low pedestal, which gives the big form an intimate relationship to the grave. As one approaches it from the south down a garden path, the statue is silhouetted against the Paris sky, for the ground beyond it falls rapidly away towards the Seine. Standing in front of the tomb, one sees *The Thinker* framed by the handsome old chateau façade, whose modest height allows the scale and proportions of the sculpture to be seen in appropriate relation to it. The columns of the entrance reiterate the figure's cubic form, and the dynamic design of *The Thinker* prevents the formal symmetry of the whole from being cold and rigid.

A photograph taken during the 1917 funeral service shows *The Thinker* in a new context, poised on the edge of the open grave, as if looking into it at

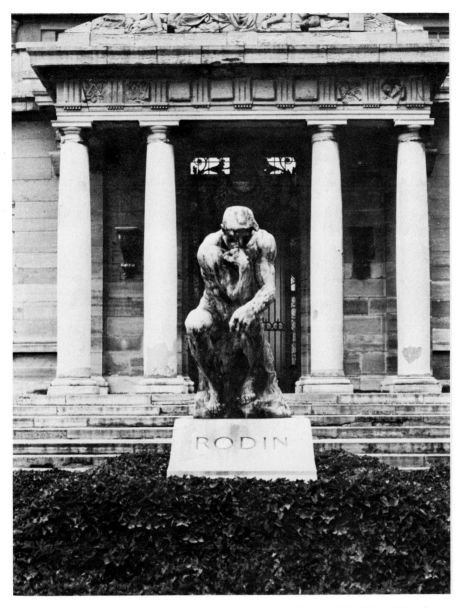

55 *The Thinker* above the grave of Auguste and Rose Rodin at Meudon.

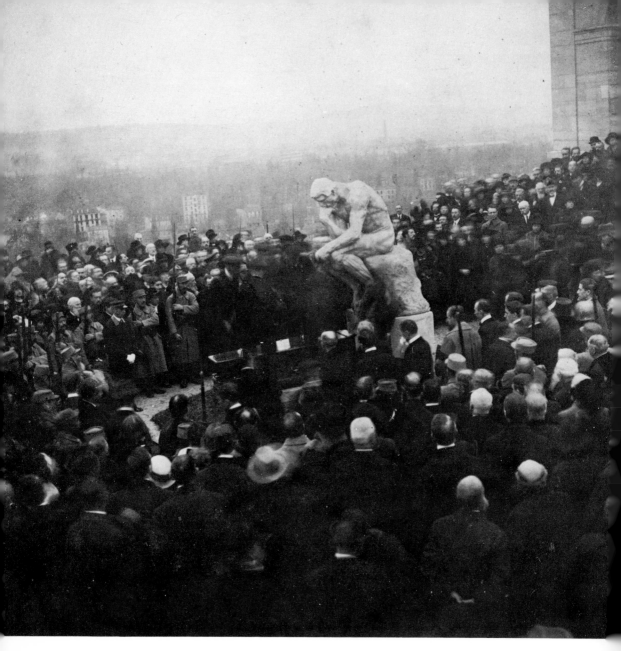

56 Rodin's funeral, November 24, 1917, Meudon.

his maker, evoking still another ancient message: art is long, life is brief (fig. 56). It was as if Rodin waited until the end of his life to leave us his last word on *The Thinker's* identity. Directly beneath the sculpture, inscribed in large capital letters on the front of the pedestal, is a single word that identifies both the statue and the artist: RODIN. — *Sweeping claim!*

PART THREE

Exploitation of "The Thinker"

Almost since the time of its installation before the Pantheon in Paris, *The Thinker* has been exploited by caricaturists and commercial artists. On the cover of the May 11, 1907 French humor weekly *Le Rire* appeared a caricature signed, "To Rodin, respectfully C. Léandre" (fig. 57). (Léandre was a gifted caricaturist who occasionally made small sculptural satires of his victims.) It shows a huge naked man seated on a large beer stein in a mushroom patch in the pose of *The Thinker*. Above the drawing appears the punning title, "Le Panseur." (The German noun *pansen* means paunch.) Below this coarse caricature of the Kaiser, a fair reflection of French views toward the Boche, runs the caption, "I am like Clemenceau . . . I feel that I am going to have need of small papers." Léandre was not original in his vulgarity, as is clear from earlier published criticism of the statue.

One of the earliest commercial exploitations of Rodin's statue appeared in a December 1908 issue of *L'Illustration* and employs a photograph of the figure on its cubic pedestal (fig. 58). It is an advertisement for Onoto fountain pens, one of which is vertically suspended in front of *The Thinker*, as if he were looking at it. With a sense of irony if not history, the commercial artist used the pedestal for his client's legend: "The Thinker of Rodin. He thinks of the time lost by those who do not own an Onoto. The Onoto, the best

57

58

fountain pen that can refill itself in 3 seconds and can be carried in the pocket in all positions."

These examples are prototypical of the uses and abuses to which Rodin's work of art is submitted. That they were found in the files of the Musée Rodin argues that the sculptor, through his clipping services or the alertness of a friend or secretary, was aware of what was happening. If he had strong views on the subject, we have not so far learned of them.

Looking at *The Thinker* through the eyes of caricaturists and commercial artists, we can see what they thought was exploitable in this sculpture that we think we know by heart. Its compact cubic form, somewhat higher than it is wide or deep, lends itself nicely to vertical, square, and horizontal layouts. Its strong design from all profiles allows a choice of angles from at least 180 degrees that take in the sides and the front, from eye level and below. The figure is unclothed (making it dateless), seated, and tense. From every profile the strong and healthy body is emphatically masculine. The figure's right hand signifies a gesture of thought, while the left hand is empty, so that something can be put into it. The large head, strongly emphasized through design and proportion, is bowed, suggesting either that he is absorbed in thought or that he is looking down at something. He sits on a common object with a closed contour that, as Léandre demonstrated, is easily replaced by another object.

What Has Been Done to "The Thinker's" Body

From the author's own file, admittedly far from exhaustive on the subject and largely restricted to American examples, it appears that with one glaring exception *The Thinker* has been manipulated by means of photographs, drawings, or copies. His pose has been aped by a woman ("The Thinkher"), a teddy bear, a donkey, and an elephant. His left hand has been made to hold a newspaper, a magazine, a wine glass, an aerosol can, the string of a yo-yo, toilet paper, and a printout, such as an EKG or brain scan. It has been made to type on a computer keyboard. In one instance the left hand was used to

In Philadelphia nearly everybody reads The Bulletin

Donald B. Poynter, Poynter Products,
Inc., Cincinnati.

toss or juggle a symbol for the sun or an atom, and most recently it has been covered with pine tar. On one occasion his right hand held a glass of milk. Earphones attached to a portable radio have been set over his ears, and he has worn an astronaut's outfit and track shorts. The rock has been replaced by a can of pine tar.

97 WYNY FM Radio, New York. NBC Corp.

It is *The Thinker*'s head, however, that has been most often the focus of caricature and advertisements. Once it was surmounted by a dunce cap made out of a crossword puzzle. It has been replaced by the head of President Jimmy Carter, presidential aspirants Gary Hart and Jerry Brown, and the president of the American League, Lee McPhail. (Not surprisingly, Ronald Reagan seems safe from identification with this embodiment of thought even by Republican cartoonists.) Reflecting the vogue for TV personalities, in 1983 *The Thinker* was given a "Mr. T" haircut. In this electronic age it was inevitable that *The Thinker*'s head should become a computer console and a keyboard should rest on his lap. The administration of the California Palace of the Legion of Honor allowed electrodes to be taped to the head of the statue in front of the museum, so that it could be photographed for the cover of a magazine. To illustrate what *The Thinker* is thinking, sometimes his head is shown in cross section, revealing a computer or a woman's head, but usually there is a balloon that includes words, product names, and/or images, even another work of art.

Courtesy of Ken Alexander

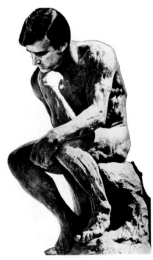

Reprinted from The San Francisco Examiner.

Reprinted with permission, Minneapolis Star and Tribune.

Reprinted with permission, NY Daily News.

'I think I am, therefore'

Vol. III, No. 5 $2.00

THE INNER WORLD

Will Science Listen?

STARGATE: Mind-Warping Into the 21st Century

Tomorrow's Medical Clinic Today!

Are You a Body... Or Pure Mind?

Photo: John Larson, © New Realities Magazine, San Francisco.

What "The Thinker" Is Thinking About

When used by editorial cartoonists *The Thinker* may be confronting a single difficult decision, like the problem of aerosol cans, or several hard choices such as usually face the President or a presidential candidate. Symbols of political parties imitate his pose in their quandary over how to get candidates to run. He may be burdened with many things, like a labor mediator snowed under by grievances, or he may ponder the consequences of an act, like Lee McPhail after the George Brett pine-tarred baseball bat incident. Sometimes he is confronted with an unsolvable problem, such as the disposal of atomic wastes, or he expresses sorrow over the political misfortunes of a New England governor. For those interested in improving the mind what he is thinking is not as important as his exemplary powers of concentration.

For advertisers, Rodin's sculpture can sit still for a host of things. He is associated with "smart money." He can induce the consumer to reflect before buying a house or remind potential advertisers that consumers can be discriminating. He can patiently watch paint dry or wait for interest rates to come down or hesitate about taking action to fight a piece of legislation opposed by a clothing store. His nakedness is a natural inducement to reflect on what light summer clothes to wear. Was there ever a better image of the intellectual gamesman, especially when it comes to chess or puzzles? The graduate student who needs thesis paper or the language student who struggles with French verb cards can identify with the mental effort suggested by this statue. Appropriately, the federal government assigns the naked cogitator the role of representing the public that wants to know about changes made in the Code of Federal Regulations.

Shut off from the world and involuted, *The Thinker* epitomizes the condition of experiencing the unspeakable: the private pain of hemorrhoids or irregularity. The name of the manufacturer is all that is needed when the seated man is drawn on the wrapper of what the French call "papier hygenique" or "Le Panseur's" necesssary "little papers" for "brains and bottoms." Who better signifies thinking about the basic pleasures such as booze? *The*

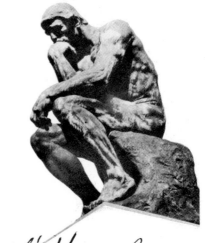

WHEN
YOU THINK
OF A.
SUMMER SUIT...

Be sure it's Haspel

Courtesy Visual Education Assn.
Springfield, Ohio.

Marcus Hamilton

Thinker is the obvious choice to promote continuing higher education or public lectures on "Symptoms of Being Normal," "Secrets of Sex Magnetism," and "The Christian Science View of Intelligence." Who is more appropriate to think about improving mind and body through self-hyponosis to give up alcohol and smoking, or by listening to popular music on a certain radio station while drinking milk and wearing running shorts? Think of the delight of the designer who had been agonizing over the cover for the annual report of a perfume company when he had a vision of *The Thinker*. The pertinence of the primal problem solver seems perpetual.

Recall that *The Thinker* was derived in part from the ancient *Belvedere Torso* that for centuries signified Sculpture. How fitting that an artist working for the *Detroit Free Press* chose to have *The Thinker* replace an American president as the central image on the Arts Dollar that seems always to be cut.

The Thinker has had a long life in cartoons, but one bids to be the classic. It appeared in the June 29, 1981 issue of *The New Yorker*. Drawn in dots by Mankoff, he is shown thinking about *The Kiss*. The cartoonist may have known that *The Kiss* was first destined for *The Gates of Hell*. According to Rodin, *The Gates* are about "love in its different phases," and *The Thinker*, Rodin's surrogate, represents the creator who conceived these themes in his head. Mankoff's cartoon is thus both amusing and historically appropriate.

The Effect of "The Thinker's" Exploitation

Such long-term and widespread exploitation of *The Thinker*'s image in the media, far from making it passé, seems to have challenged commercial artists to find for it new and surprising contexts. What business could not be represented by *The Thinker*? This sculpture is strongly rooted in the public mind, so applicable to various situations, that cartoonists seem not to hesitate to draw from it on short notice. From Léandre's dedication in 1907, to Bill Gallo's "Thanks Auguste Rodin—you came through again," in *The Daily News* in 1983, most artists have used *The Thinker* with respect.

The worst offender of taste may be not a business that makes generic medicines to treat body disorders, but perhaps an art museum, the California

The arts

How states rank in support of arts

When it comes to supporting the arts, Michigan does well nationally and far better than its Midwestern neighbors. "It's been extraordinary, with Michigan's economy in the swoon it's been in. It seems to me the state is to be congratulated for its support of the arts," said

Drawing by Mankoff; © 1981
The New Yorker Magazine, Inc.

Palace of the Legion of Honor. A museum's prime function should be to preserve the integrity of the art intrusted to it. Instead of refusing to allow its actual cast of *The Thinker* to be utilized, thereby leaving it to the advertiser to work with a copy or photographs, this museum appears to have set an example that makes it very hard to continue educating the public to respect art out of doors and to consider disrespect for art, if not vandalism, socially unacceptable.

The Thinker is so strong an image that no commercial interest has succeeded in preempting it. The mere fact of its continued exploitation, therefore, reminds us of the power of Rodin's art. For the thousands who know *The Thinker* only through reproductions and commercial exploitations, seeing an actual cast in front of a museum or on a university campus is usually a genuine thrill. That power to thrill may be the final test of this sculpture's durability and prove whether or not it has been harmed by manipulation and overexposure.

Coda: *Last Thoughts on "The Thinker"*

In 1918, the famous American art historian, Charles Rufus Morey, wrote:

> The Penseur ... in my opinion, is not destined to live as the masterpiece of Rodin; it is too early. Exhibited first in plaster in 1889, it belongs to those works wherein his technique was feeling its way toward a really modern expression and the ideal concept which he has in mind only emphasizes the powerful modeling, instead of subordinating it to the theme. Compare, for example, the ease with which we translate the muscularity of Michelangelo's Moses into terms of intellect; in contrast to this the net impression of Rodin's figure is physical. (p. 150)

Morey's views help to explain why art historians in this century have not focused on *The Thinker*. It comes too early in his art, before *The Burghers of Calais* and *The Monument to Balzac*, and above all before the études, including the partial figures that had the greatest impact on early twentieth-century

sculptors. Rodin is so identified with natural movement that his postural paraphrase of Michelangelo's figures could have counted against historical judgment of *The Thinker*.

Compared with the impact of his *Walking Man*, the influence of this statue on specific works of art has seemed slight. Sometime before 1900, French sculptor Joseph Bernard adopted the pose of *The Thinker* for his own figure of despair in Vienne. (The exact original title is unknown even to his son Jean, the great bronze founder who supervised the most recent and finest casting of *The Gates of Hell*.) In 1902, Edward Steichen made two dramatic photographs of the sculptor posed with *The Thinker* "for Rodin," as he put it, and they may have helped the artist's reputation considerably in this country. Gustav Vigelund's *Lucifer* in his relief of *Hell*, made in 1893, has its source in the tympanum of *The Gates of Hell*. *The Thinker* had to have been the inspiration for Lehmbruck's *Seated Youth* of 1917, Lipchitz's question-mark-like *Seated Figure* of 1925, probably Duane Hanson's seated and reflective *Hard Hat*, and certainly Robert Moskowitz's big drawing and painting of *The Thinker* exhibited in 1983. But this is not an impressive showing.[1] Modern sculptors early in this century rejected muscular tension or, as Brancusi called it, "beefsteak art." A fundamental commandment of modernism from Cézanne and Matisse almost to the present has been "thou shalt not depict expression." Expression must reside in self-expression and the whole arrangement of the work, not in the emotions depicted by the figure's face and hands or a tensed body. As if this were not enough, the sustained public popularity of this ubiquitous image may have been off-putting to artists, as well as art historians.

Although he reflected the view of Rodin's lifetime critics that *The Thinker* flunked in decorum when compared to Michelangelo, Morey was right in seeing the sculpture's importance for Rodin. It may be a distinguishing characteristic of great artists that early in their careers they choose great exemplars by which to confront nature in their art and their results stand up to the prototype. By naturalizing Michelangelo's art of the Medici tombs and Sistine Ceiling in *The Thinker* and *Adam and Eve*, Rodin built an art based on life. Long after he had stopped paraphrasing Michelangelo's expressive gestures and structuring of the limbs, Rodin used his own compositional "cubism" that

may well have come from the older artist's block esthetic: visualizing a figure within the shape of the quarried stone.

Now that naturalistic rendering of figures in painting and sculpture is more widely practiced, even to the extent of life-casting, and has again won critical acceptance, artists are less embarrassed to look at *The Thinker* in terms of its form. Robert Moskowitz, who has been interested in depicting three-dimensional subjects on a two-dimensional surface, commented to the author on the powerful masculinity he observed in *The Thinker*'s silhouette as he drew it and straightened out its curves.

The private side of this most public sculpture, referred to at the book's outset, includes its rich history within Rodin's own art and life. Within *The Gates of Hell*, *The Thinker* is the infernal poet-voyager, like Dante and Baudelaire, that historical fraternity of creators who have probed the dark side of life and humanity's fear. For Rodin the noblest mission of the artist, represented by his silent, pensive worker, was the visualization and recreation of society in art, and he yielded nothing to Hugo, Balzac, and Baudelaire in this mission. They were all worker-poet-artists celebrated in one sculpture. Far from being illustrative, Rodin's art takes up where words leave off. Reading that *The Thinker* embodies the active and contemplative life of the creator pales beside the seeing of it.

In the history of sculpture one might say that *The Thinker* belongs to the category of personification or allegorical art, except that he is what he represents. The statue's modernity does not reside in having a meaning that comes out of a public source, as does that of *The Statue of Liberty*. Rodin's statue may be seen as the last of the great nineteenth-century monuments, but even then it is an uncertain, even indefinite monument exemplifying the dilemmas of modern public sculpture. It evokes rather than answers questions in the public's mind. Unlike its predecessors in the last century, *The Thinker*'s meaning is equivocal or unresolved, susceptible to more than one interpretation and often dependent upon its physical and temporal context, as well as upon the viewer's culture. This equivocal identity may have been one of the reasons the statue was removed from the front of the Pantheon.

The mobility of *The Thinker*'s meaning can be found in Rodin's own reactions to it. Beside those comments earlier cited, in his book *The Cathedrals*

of France Rodin wrote of his visit to the crypt of the cathedral at Rheims, "A candle burns: a tiny point of light: to reach it I must stride over heavy masses of shadow where I rub against . . . unicorns, monsters, visions. *The Thinker* would have been well adapted to this crypt, this immense shadow would have fortified that work."[2]

The Thinker's many lives are thus due to its amazing capacity for renewed relevance. In the 1880s Rodin made the point through his sculpture that in society the artist alone was thoughtful. Only he could present humanity with a compassionate image of its spiritual suffering. By means of this sculpture Rodin democratized the image of the artist. His powerful body signified the physical work of art, while his concentrated thought evoked the intellectual demands of the creative process. In the bitter social disruption of the early 1900s, *The Thinker* won renewed significance. In its special site before the Pantheon, this statue seemed to impart social dignity to the French workers by elevating them to the status of national heroes. Between the two world wars, by its location in universities and before museums, *The Thinker* became an international symbol of education and art. In the 1980s, when everything is being done to eliminate hard physical labor by means of electronics, there is an accompanying mania for improving health through diet, exercise, and body building. No longer seen as the primal brute, Rodin's statue has ironically found a new decorum. *The Thinker* gives the new muscular intellectual of our time not only respectability and an ideal image of self, but a monument!

Notes

Part One: The History of *The Thinker* to 1900

1 The best available lists of the casts of *The Thinker* in its three sizes can be found in Tancock's *The Sculpture of Auguste Rodin*, pp. 120–21. The three sizes listed in Tancock in the order of their creation are: the original version that went into *The Gates of Hell*, 27⅛″ × 15¾″ × 19¾″, the enlargement, 79″ × 51¼″ × 55¼″, and the reduction, which is 16″ high. But not all castings are identical and measurements vary, often according to who is taking them, so it is difficult to determine exact measurements.

Following is a list of the locations of the enlarged version of *The Thinker*, compiled from Tancock and the booklet by de Caso and Sanders, *Rodin's Thinker*, San Francisco, 1973, augmented by some recent additions supplied to me by Vera Green, curator of the B. G. Cantor Art Collections.

In the United States:

Baltimore, Baltimore Museum of Art. Jacob Epstein Collection. Cast by Alexis Rudier.

Cleveland, Cleveland Museum of Art. Gift of Ralph King, 1917. Cast by Alexis Rudier.

Denver, Columbia Savings and Loan Association, Cherry Creek Office. Purchased in 1966. Cast by Georges Rudier.

Detroit, Detroit Institute of Arts. Gift of Horace H. Rackham, 1922 (ex-collection Dr. and Mrs. Linde, Lubeck). Cast by Alexis Rudier.

Louisville, Allen R. Hite Art Institute, University of Louisville. On loan from the City of Louisville. Cast by Hébrard.

New York City, Columbia University. Acquired in 1930. Cast by Alexis Rudier.

New York City, The B. Gerald Cantor Sculpture Center, property of the B. G. Cantor Collection. Cast by Georges Rudier.

Pasadena, The Norton Simon Museum, property of the Norton Simon Foundation. Cast by Georges Rudier.

Philadelphia, The Rodin Museum of Philadelphia. Gift of Jules Mastbaum. Cast by Alexis Rudier, 1928.

San Francisco, California Palace of the Legion of Honor. Given to the city and county of San Francisco, 1916. Cast by Alexis Rudier.

In the World:

Buenos Aires, Plaza del Congresso. Property of the City of Buenos Aires.

Bielefeld, West Germany, Kunsthalle Richard Kaselowsky-Haus. Acquired in 1968. Cast by Georges Rudier.

Copenhagen, Denmark, Ny Carlsberg Glyptotek. Purchased by Carl Jacobsen in 1906.

Kyoto, Japan, Kyoto National Museum.

Laeken, Belgium. This is now a suburb of Brussels, and the cast is in the cemetery near the royal palace.

Meudon, Musée Rodin, placed over the grave of Rose and Auguste Rodin on the artist's instructions. Cast in 1917 by Alexis Rudier.

Moscow, State Pushkin Museum of Fine Arts.

Nagoya, Japan, Municipal Museum. Cast by Georges Rudier.

Paris, Musée Rodin. Cast originally installed in front of the Pantheon in 1906 and removed by order of the Ministry of Public Instruction to the Musée Rodin in 1922. Cast by Hébrard.

Stockholm, Prins Eugens Waldermarsudde. Purchased in 1909. Cast by Hébrard.

Tokyo, National Museum of Western Art (ex-collection Matsukata). Cast by Alexis Rudier.

2 For an excellent history of this mon-

ument, see Marvin Trachtenberg, *The Statue of Liberty* (New York: Viking, 1976).

3 For the best short accounts of *The Thinker* see Tancock, pp. 111–16; de Caso and Sanders, *Rodin's Sculpture: A Critical Study of the Spreckels Collection*, pp. 131–38. Both of these catalogues have extensive bibliographies. See also Butler, *The Early Work of Rodin*, pp. 218–23.

4 Quoted in Adam, *Saturday Night*.

5 For medical opinions on the age of the model who posed for *The Thinker*, as well as verification of certain anatomical distortions, I am indebted to two fine physicians, William Fielder and Gary Fry.

6 Mauclair, *Auguste Rodin*, p. 56.

7 Ibid., p. 66. (Translations unless otherwise noted are by the author.) Rodin told Mauclair that Michelangelo "understood that an architecture can be built up with the human body, and that in order to possess volume and harmony, a statue or a group ought to be contained in a cube, a pyramid, or some simple figure." Judith Cladel in *Rodin: Sa vie*, p. 401, wrote that Rodin's maxim was "The sense of the cube is the mistress of things and not appearance."

8 Rodin analyzed Michelangelo's *Captives* from the Tomb of Julius the Second for Paul Gsell and commented, "Let us consider . . . the general aspect. It is that of a console; bent legs project, the retreating chest forms a hollow." Turning to another Captive, Rodin went on: "Here again the form of the console is designed, not by the retreating chest, but by the raised elbow, which hangs forward. . . . this particular silhouette is that of all the statuary of the Middle Ages." Gsell, *Rodin on Art*. A more accurate translation of

Gsell's conversations with Rodin by Jacques de Caso and Patricia Sanders will be published by the University of California Press.

9　Rodin shared with his secretary Anthony Ludovici his intentions for a work known as *La Pensée* ("Thought") that showed the head of a woman with a cap atop a block of rough-hewn marble: "He said it was an experiment. He wished to see whether he could make the head so exuberantly alive, so pulsating with life, that it imparted vitality even to the inert mass of marble beneath it. 'I wanted the marble below to look as if the blood from the head were circulating through it.'" Ludovici, *Personal Reminiscences of Auguste Rodin*, p. 71. After citing the above quotation, Tancock comments without explanation, "The experiment cannot be described as particularly successful nor the ambition an elevated one" (p. 590). In terms of the contemporary reaction it produced the experiment was successful, and when viewed in the context of the artist's life-long transformation of his materials into artistic life, it could be called a noble ambition. Rodin was simply attempting the Pygmalion dream.

10　To my knowledge the first scholar to discuss this work seriously was J. A. Schmoll in *Torso: das Unvollendete als Kunstlerische Form*, p. 24. See also Schmoll, *Der Torso als Symbol und Form*. All the objects that comprised the stone *Trophy of the Arts*—such as the lute, the book, and the drapery—may have been carved directly from actual objects.

11　So that his small figures of études could be variously oriented without regard to gravity, Rodin rarely mounted them on socles. Figures that had been originally modeled upright might be reoriented without ad-

justment to the modeling and musculature of the body. Artistic credibility took precedence for Rodin over the laws of physics and anatomy. The best discussion of this aspect of Rodin's art can be found in Leo Steinberg's exemplary essay "Rodin" in his *Other Criteria* (New York, 1972).

12　Rodin's long letter to Rose Beuret is cited in full by Cladel, *Rodin: Sa vie*, p. 111–12. In it he comments that the Medici Chapel in San Lorenzo impressed him the most, that it was necessary to study the tombs from three-quarter and profile views, and that he made sketches from memory at night in his room in order to fathom Michelangelo's secrets. "I made drawings . . . not after his works, but after the scaffoldings, the systems that I fabricate in my imagination in order to understand him." Cladel also quotes a 1906 letter from Rodin to the sculptor Bourdelle in which he credits Michelangelo for having liberated him from academic rules.

13　For a full discussion of the Loos monument see Alhadeff, "Michelangelo and the Early Rodin," pp. 363–67. Rodin's own account of the monument follows: "I worked on these figures with the greatest ardor from a decorative point of view, and it was while I was making the figure of the sailor that I was struck with its resemblance to the statues of Michelangelo, though I had not had him in mind. I had always admired Michelangelo, but I saw him from a great distance. My studies had been a blind search for the movement of figures, and in making this one, I was for the first time impressed with its resemblance to the compositions of the great Florentine." This is from a series of articles

by Truman H. Bartlett that first appeared in the *American Architect and Building News* in 1889 and have been reprinted in my *Auguste Rodin: Readings*, p. 30. (Hereafter referred to as Bartlett.)

14 For an important discussion of the drawings Rodin made during his trip, see Kirk Varnedoe's "Rodin's Drawings," esp. the subsection, "The Trip to Italy," in my *Rodin Rediscovered*, pp. 161–66. I do not agree with Varnedoe that Michelangelo had no serious influence on *The Age of Bronze*, which Rodin said had "four figures in it," or on *The Thinker*. Michelangelo's influence on the former can be seen in its console profile and in its paraphrase of the pose of Michelangelo's *Bound Slave* (in the Louvre). Those for the influence on *The Thinker* follow in the text.

15 For a full discussion of *The Vase of the Titans*, see Janson, "Rodin and Carrier-Belleuse," pp. 278–80.

16 "I believed before that, that movement was the whole secret of this art, and I put my models into positions like those of Michelangelo. But as I went on observing the free attitudes of my models I perceived that they possesed these *naturally*, and that Michelangelo had not preconceived them, but merely transcribed them according to the personal inspiration of human beings moved by the need of action. I went to Rome to look for what may be found everywhere: the latent heroic in every natural movement." Mauclair, *Auguste Rodin*, p. 65.

17 For a more complete discussion of *The Ugolino* see my *In Rodin's Studio*, pp. 158–59. In the letter to Rose (in the archives of the Musée Rodin), Rodin complains, "the mouleur demands that I pay 150 francs for having cast my Ugolino, and I will not pay it." This

letter was probably written in the summer of 1877.

18 My source for this information is Claudie Judrin, curator of drawings at the Musée Rodin, who has made a study of Rodin's art collection. For a view of Carpeaux's influence on *The Thinker*, see Butler, *The Early Work*, p. 220. She sees identical treatment of the feet, but *Ugolino*'s feet are on top of one another. I do not agree with her that Carpeaux's *Ugolino* has more "cross-rhythms" than Michelangelo's tomb figures.

19 This wax figure appears to be unique, and to my knowledge there is no cast of it in the reserves of the Musée Rodin. It was most uncharacteristic of Rodin to part with a unique sculpture, as he prefererd to give away or sell casts of his work. How the sculpture left the studio and eventually found its way to Kansas City is not clear. I have personally examined this wax and find it to be authentic, and to my knowledge no Rodin scholar has disputed its authenticity. Its 1875 date is supported by Alhadeff and Butler.

20 In effect, Rodin reoriented Michelangelo's reclining *Adam* on the ceiling of the Sistine Chapel so that it seems to be a vertical statue of his own Adam. Seeing Michelangelo's figures on this ceiling from different viewpoints may have inspired Rodin to put his own figures into different orientations defying gravitational relationships.

21 In the catalogue of the Nelson-Atkins Museum, the work is described as a study for the *Sailor* of the Loos Monument, following Alhadeff's argument.

22 Alhadeff argues in "Michelangelo and the Early Rodin" that Rodin did not use more than one mode after a certain period; he assumes that Rodin relentlessly evolved his

style without keeping his options open. But when *The Kiss* was shown in public in the 1880s, for example, it was the nudity of the lovers that was shocking, not the lack of finish by Salon standards, as was also the case with *The Thinker* when the enlarged version was exhibited in 1904. To my mind the pose of the wax figure, particularly the gesture of the left arm (which Alhadeff describes as simply hanging at his side) disqualifies it as a study for *Industry* or *The Sailor*. It is so detailed that one wonders why no attribute was given, unless the gripping of the rock signifies the man's vocation as an artist. If the work was done after the Italian trip as a private study after Michelangelo, the detail is surprising and out of character for Rodin.

23 Art historians have proposed as sources for *The Thinker* such works as Feuchère's *Satan*, Blake's *Jerusalem Delivered*, Duret's *Chocatas Mourning Atala*, and so on. None of these scholars makes the case that his or her nomination rather than Michelangelo, for example, was a stronger influence. The implication is that Rodin learned nothing from or forgot Goujon, Apollonios, and Michelangelo, but upon seeing one of the other works was inspired to make *The Thinker* or else, pondering the work, selected one for inspiration.

24 These drawings are reproduced in my *Rodin's Gates of Hell*, plates 33, 36, and 38; and in my book *The Gates of Hell by Auguste Rodin*, Stanford: Stanford University Press, forthcoming.

25 "The Thinker descends from a long line of mourning figures that appear in Rodin's drawings from earlier years." Varnedoe, "Rodin's Drawings," p. 165. This statement could well be true, but Rodin was not

inclined to make sculptures from drawings, as Varnedoe himself has pointed out. Both the wax figure and *The Ugolino* are more compelling ancestors. Another reason I am not completely persuaded of a source in drawings is that none of the sketched figures performs anything like the function of *The Thinker* in *The Gates*, particularly in his centrality and isolation from the surrounding action.

26 Other sculptural sources for portraits of Dante included Baron Henri de Triqueti's *Dante and Virgil* of 1862, and Antoine-Augustine Préault's medallion bust. For reproductions of these works, see Fusco and Janson, *The Romantics to Rodin*. See also Mower, "Antoine-Augustin Préault," p. 305.

27 For a discussion of Rodin and his photographers and use of photographs see my *In Rodin's Studio*.

28 See *The Gates of Hell by Auguste Rodin*, especially "The Sculptor's Gamble."

29 This drawing is reproduced in my *Rodin's Gates of Hell*, plate 19.

30 Bartlett's notes are housed in the Library of Congress.

31 See Thorson, *Rodin's Graphics: A Catalogue Raisonné*, pp. 84ff.

32 The Ionides letters are in the archives of the Musée Rodin.

33 Shroder questions Hugo's sincerity and attributes his views to pity.

34 I have gone further into this subject in my forthcoming *Gates of Hell by Auguste Rodin*. See also Butler, *Literary Aspects in the Work of Auguste Rodin*.

35 *Gil Blas*, Paris, July 7, 1904.

36 For an account of Rodin's *Tower of Labor* see Descharnes and Chabrun, *Auguste Rodin*, pp. 146–53.

37 Cladel, *Rodin: Sa vie*, p. 137. Cladel

explains Rodin's self-nomination as a "mason of art" by his years of anonymous hard labor in making a living. Mauclair quotes Rodin, "I do not deny there is exaltation in my works; but that exaltation existed not in me, but in nature, in movement . . . my temperament is not 'exalted'; it is patient. I am not a dreamer, but a mathematician." *Auguste Rodin*, pp. 68–69.

38 For an illuminating discussion of this work see de Caso and Sanders, *Rodin's Sculpture*, pp. 49–50.

39 The comment that *The Thinker* "is not destined for the corner of the tomb of a Lamoricière" refers to Paul Dubois's *Military Courage*, shown in the Salon of 1876 and later placed at a corner of the Monument to the Memory of General Juchault de Lamoricière in the cathedral of Nantes. For a discussion of DuBois's work, see Fusco and Janson, *The Romantics*, pp. 243–45.

40 The clipping in the archives of the Musée Rodin does not include the title of the newspaper.

41 Mauclair, "L'Art de Monsieur Rodin."

42 Maillard, *Auguste Rodin, Statuaire*, pp. 81–82.

43 Basset, "La Porte de l'Enfer."

44 Rainer Maria Rilke, "Auguste Rodin" (1903), reprinted in my *Auguste Rodin: Readings*, p. 121.

45 Several of Rodin's biographers, e.g., Cladel and Bénédite, write that the work on *The Gates of Hell* lasted twenty years. I discuss the question of whether the portal was complete in 1900 in my forthcoming *Gates of Hell by Auguste Rodin*.

46 Dante Alighieri, *The Divine Comedy*,

trans. Carlyle-Wicksteed (New York, 1932), p. 29.

47 I am indebted to Walter Mischel, distinguished pyschologist and former Stanford colleague, for this observation during one of our many animated luncheons.

In his long life and many liaisons with women, Rodin supposedly fathered only one child, Auguste Beuret, who was born the year he met Rose, the boy's mother. One of my former graduate students, Marion Hare, has done some research into the subject and is of the opinion that Rodin may not have been the biological father of young Auguste. (Paper in the author's files.) In the days before modern methods of contraception, it seems unusual that Rodin did not father at least one more child—unless he was sterile. No one claimed the existence of such a child at the time of Rodin's death, nor are any mentioned or even rumored in the considerable contemporary literature on the artist, even though Rodin, a notorious womanizer, was ripe for gossip.

It is probable that Rodin was aware that while sexually active, he was sterile. *The Thinker* was made more than fifteen years after Rodin met Rose, and especially if he were not the natural father of young Auguste, this awareness could have been manifest, consciously or not, when he worked on the sculpture. All artists presumably look upon their works of art as their offspring, but in Rodin's case they may have been his only progeny, giving additional meaning to *The Thinker*, who cannot reproduce himself biologically.

**Part Two: The Dilemmas of Modern
Public Sculpture**

1 The importance of Rodin's études for
modern sculpture was the subject of my lec-
ture "Rodin's Sculpture for Sculptors," which
will be published by the Metropolitan Mu-
seum of Art as part of the Yaseen Studies in
Modern Sculpture.

2 I have written about the relationship
of Rodin to the man who reproduced his
works in "Rodin's Perfect 'Collaborator,'
Henri Lebossé," in *Rodin Rediscovered*.

3 Such a decision was not unusual for
Rodin. He often made his reliefs by first
modeling the figures in the round and then
slicing off what he did not need. Rodin made
his relief of *La France* by pushing the full bust
through a perforated cardboard. See *In Ro-
din's Studio*, p. 22.

4 This practice is described in my "Ro-
din's Sculpture for Sculptors."

5 Monique Laurent, "Observations on
Rodin and His Founders," *Rodin Rediscov-
ered*, p. 200.

6 Thiébault-Sisson, "Le Penseur de
Rodin."

7 Laurent, "Rodin and His Founders."

8 De Caso and Sanders cite Rodin's re-
quest to have the cast removed from the ex-
hibition in *Rodin's Sculpture*, p. 137.

9 Mauclair, *Auguste Rodin*, pp. 87–88.

10 "A la Nationale," *La Revue Mondiale*.

11 "La Salon de la Société Nationale,"
La Quinzaine, May 18, 1904.

12 Mourey, *Les Arts de la Vie*, June 1904.
Mourey had written on Rodin in 1898 and
was enthusiastic about the *Tower of Labor*
project. Successive issues of his magazine
carried information on the subscription drive.

13 An article signed V., "Notes Pari-
siennes." On the subject of the subscription
see also Tancock, pp. 114–15.

14 On December 6, 1904, the subscrip-
tion committee formally offered to give the
bronze cast of *The Thinker* to the State in a
letter to the Minister of Public Instruction, J.
Chaumié, signed by Mourey and Geffroy:
"In the month of May last, under the initi-
ative of the Review Les Arts de la Vie a com-
mittee was formed to acquire and give to the
people of Paris the statue of The Thinker by
Auguste Rodin. This committee . . . closes to-
day the public subscription opened for this
purpose, and has the honor to offer this mas-
terpiece to the State, to be placed in front of
the Pantheon in the inclosure of the monu-
ment. Our wish is that the following inscrip-
tion be carved on the base:

> The Thinker
> by Auguste Rodin
> offered
> by Public Subscription
> to the
> People of Paris
> 1904

"We know your constant solicitude for
the important interests under your care and
we await with confidence your decision for
this manifestation of the glory of the tradi-
tion and liberty of Art in France, and of the
great artist who represents it so highly among
us today."

Chaumié replied: "I hasten to make known

to you that I very willingly accept in the name of the State, the generous offer of the Committee whose initiative will be recalled by the inscription placed on the base." This is from *A Short Notice on The Thinker by Auguste Rodin and the Rodin Museum*, published by Tiffany (New York, 1914), on the occasion of their offering a cast of the statue for sale. (This obscure brochure is in the Horst W. Janson photographic archives, Art Department Library, New York University.)

15 This was not the last time such an excuse would be used to prevent the installation of a major Rodin work in a brilliant location. In 1912 the French ambassador to Italy ordered the removal of *The Walking Man* from the courtyard of the Farnese Palace in Rome on these grounds. The same excuse was given a few years ago by the director of the Stanford University Art Museum, who objected to the sculpture's location in the museum's large glass-domed rotunda, perhaps the most beautiful indoor location ever for the work. He had *The Walking Man* removed to a poorly lighted, low-ceiling lobby of another building, where it was definitely in the direct line of traffic.

16 Maillard, "Notes sur Rodin."

17 The Courtot dossier is in the archives of the Musée Rodin.

18 See my article, "Picasso's *Man with a Sheep*."

19 Gordon Wright, *France in Modern Times: 1760 to the Present* (Chicago, 1960), p. 338.

20 Cited by Judrin, *Rodin et les écrivains de son temps*, p. 60. This is very valuable book.

21 "Le 'Penseur' de Rodin," *Le Temps*. For a translation of the entire speech by John Anzalone, see Butler, *Rodin in Perspective*, pp. 119–21. I have not used this translation, as I found it too inexact. For example, Dujardin-Beaumetz said, "il est calme dans sa force, car il ne la mettre qu'au service du droit." Anzalone translates this as "his is a calm strength and he will use it for just ends." Given the strikers' defiance of the law and the fact that the speaker was a government official, I prefer my translation.

22 For a good synopsis of the critical opposition to the monument see Steve McGough, "The Critical Reception of Rodin's Monument to Balzac," in Elsen, et al., *Rodin's Balzac*.

23 As Rodin had no major monument in a public place in Paris, he must have been delighted to give his assent. See Tancock, p. 112.

24 Gsell, *Rodin on Art*, esp. the chapter "On the Usefulness of the Artist."

25 National Foundation on the Arts and the Humanities Act of 1965, 20 U.S.C. sec. 951 FF.

26 This strategy is used by Stalker and Glymour in "The Malignant Object: Thoughts on Public Sculpture." In presenting the reader with what they believe are legitimate choices they employ the following strategy: "In Pittsburgh there has been popular organized resistance to a proposal to build a piece of modern cement sculpture on a vacant lot on the North Side of the city. The people of the North Side, a middle-class working community, want a fountain not a piece of sculpture" (p. 5). This may be true, but the authors do not tell us if they polled the North Side citizens or how they came by this information. While challenging potential critics to rebut them with hard objective evidence, they admit they have only "impressionistic evi-

dence" on which to base their attacks on government support of modern public sculpture. Nor do the authors reassure the reader that the same funds that would presumably bring the cement sculpture to the North Side could also be used for a fountain.

27 I would like to thank my Stanford colleagues Jody Maxmin and Michael Jameson for their help in citing this example and their illuminating discourses on Greek sumptuary laws.

28 In "The Malignant Object," Stalker and Glymour complain that the "esoteric" in modern public sculpture causes the public to feel humiliated. Their article is a convenient compendium of complaints against modern public sculpture by two armchair scholars who, while questioning the sincerity of all those responsible for this art, plead, as self-professed philistines, to be considered human. Nowhere is their casuistry more apparent than in the attempt to equate pornography with modern public sculpture. With utter disregard for differences in character or intensity, the writers equate public pornography's encouragement of sex crimes with public art's begetting "more of the same" (pp. 14–15). Just as disturbing is the authors' ignorance of the law and what constitutes pornography or obscenity. Under the 1973 Supreme Court decision (Miller *v.* California), works of art that have any serious or redeeming esthetic value are not considered obscene or pornographic. (For a discussion of this and other relevant decisions see Merryman and Elsen, *Law, Ethics, and the Visual Arts*, pp. 3–135.)

29 This observation comes from the author's personal experience of being responsible for the selection and placement of modern sculpture on the Stanford campus over a fifteen-year period.

30 "Le 'Penseur' de Rodin," *L'Univers et le Monde*.

31 Marx, *Souvenirs*, p. 96.

32 Mirbeau, *Auguste Rodin*, p. 22.

33 Quoted in Cladel, *Rodin: Sa vie*, p. 257.

34 Gabriel Boissy, *L'Idée Libre*, n.d. (probably 1904).

35 "Le Salon de la Société Nationale," *La Quinzaine*, May 18, 1904.

36 Boissy, *L'Idée Libre*, n.d.

37 "Auguste Rodin—Le Penseur," *Chroniques d'Art*.

38 Glymour and Stalker describe vandalism of modern public sculpture as "vigilantism against contemporary sculpture." They describe how "in community after community spontaneous bands of Aesthetic Avengers form." Never do they deplore acts of violence against public art—curious behavior for philosophers who say they are concerned about public well-being. Their attitude is like condoning or dignifying assassination of public officials by calling their murderers Political Avengers.

39 I am indebted to Alain Beausire, archivist at the Musée Rodin, for this information.

40 Cladel, *Rodin: Sa vie*, p. 50.

41 In a letter dated September 7, 1983, the director of the museum, Sherman Lee, gave the following background and explanation of the decision: "The decision was taken by Director and Curator first, after considerable thought and argument—including constructive conversations with Athena Tacha [a sculptor and Rodin expert]. Most curators and the Trustees were in favor of restoration. But the nature of the damage

afflicting only the lower parts, especially the rock base, made the appearance of the work clearly recognizable and reasonably complete. Two major ideas lead to the decision. After all, the attack and damage was an historical fact, as much as the magazine explosion of the Parthenon. Further, the historical context was a particularly meaningful and tragic one, at the very close of the troubled sixties and the only occasion of a direct assault on the 'ivory-tower' museum. In view of my own philosophy for the museum, this seemed worthy of perpetuation. Secondly, Rodin himself was not unpartial to historical accident—dropped wax sketches being retained in their new and 'randomly selected' form—extreme examples of the fortuitous accident made part of the fabric of the finished work. These two factors plus the readily available existence of other 'perfect' casts and

the distaste of the art lover for restoration and maintenance of 'market value,' all seemed clearly to point to the final decision. The trustees . . . unanimously ratified the recommendation of the Director and Curator [Ed Henning]. Many questions were asked at first by friends of the museum, but there was an encouraging majority acceptance of the decision and its rationale. The notation on the new black granite pedestal is simply, 'Damaged 29 March, 1970.' with the original inscription, 'The Thinker by Auguste Rodin, gift of Ralph King, 1916.' " It is my understanding that the Cleveland Museum's administration may be reviewing their previous decision.

42 Grappe, *Catalogue du Musée Rodin*, p. 25. "According to the will of the artist, The Thinker . . . adorns his tomb at Meudon."

Part Three: Exploitation of *The Thinker*

Coda: Last Thoughts on "The Thinker"

1 For reproductions of these works see Edward Steichen, *A Life in Photography*, New York, 1981. For Vigelund's *Hell* in the Nasjonalgallaeriet, Oslo, see Bo Wennberg, *French and Scandinavian Sculpture in the Nineteenth Century*, Stockholm, 1978, p. 182. Reinhold Heller, *The Art of Wilhelm Lehmbruck*, Wash-

ington, 1972, cover. Jacques Lipchitz with H. H. Arnason, *My Life in Sculpture*, London, 1972, p. 76. Robert Moskowitz, *Catalogue* for the exhibition of paintings and drawings at the Blum Helman Gallery, New York, 1983, cover.

2 Geissbuhler, *Auguste Rodin: Cathedrals of France*, p. 186.

Select Bibliography

Criticism by Rodin's Contemporaries

Adam, Marcel. *Saturday Night*, Toronto, December 1, 1917.

A. M. *L'Action Littéraire et Artistique*, May 1904.

Alexandre, Ars. *Le Figaro*, Paris, April 16, 1904.

"Auguste Rodin—Le Penseur." *Chroniques d'Art*, Paris, May 1909.

Basset, Serge. "La Porte de l'Enfer." *Le Matin*, March 19, 1900.

Boissy, Gabriel. *L'Idée Libre*, Paris, May 1904.

Baudin, Pierre. "Le Penseur et la statuaire de la rue." *Les Arts de la Vie*, Paris, June 1904.

Bouillet, Pierre. "Salon de la Société Nationale des Beaux-Arts." *Le Radical*, June 14, 1904.

Bourgeat, Fernand. "Paris Vivant." *Le Siècle*, June 20, 1889.

Brownell, H. S. *The Philadelphia Enquirer*, July 16, 1899.

Champsaur, Félicien. "He Who Returns from Hell: Auguste Rodin." *Supplement du Figaro*, January 16, 1886.

"Civil Festivals, Artists' Projects." *Le Radical*, June 5, 1905.

Cladel, Judith. *Auguste Rodin: Pris sur la vie*. Paris: La Plume, 1903.

———. *Rodin: Sa vie glorieuse, sa vie inconnue*. Paris: Bernard Grasset, def. ed., 1950.

Coquiot, Gustave. *Le Vrai Rodin*. Paris: Jules Tallandier, 1917.

"Current Art." *Magazine of Art*, 1883.

d'Auray, M. "Chronique." *Le Courrier du Soir*, June 26, 1898.

de Lassus, L. Augé. "Les Deux Penseurs, Michelange et Rodin." *Le Journal des Arts*, Paris, June 26, 1904.

Frantz, Henri. "The Great New Doorway by Rodin." *Magazine of Art*, September 1898.

Harmant, Jules. "Le Sculpture de Rodin." *L'Action Littéraire et Artistique*, May 1904.

Hennequin, Marcel. "Salon d'Automne." *L'Hermine*, December 2, 1904.

Le Journal, January 17, 1905.

Lawton, Frederick. *The Life and Work of Auguste Rodin*. Unwin, 1906.

La Liberté, November 30, 1904.

Ludovici, Anthony M. *Personal Reminiscences of Auguste Rodin*. Philadelphia: J. B.

Lippincott, 1926.

Maillard, Léon. *Auguste Rodin, Statuaire*. Paris: Floury, 1899.

———. "Notes sur Rodin." *Les Amis de Paris*, June 1923.

Marx, Roger. *Souvenirs*. Paris, n.d.

Mauclair, Camille. "L'Art de Monsieur Rodin." *La Revue des Revues*, June 18, 1898.

Milès, Roger. *Eclair*, Paris, April 1904.

Mirbeau, Octave. *Auguste Rodin*. Paris, 1918.

———. *La France*, February 18, 1885.

Morey, Charles R. "The Art of Auguste Rodin." *Art Bulletin*, September 1918.

Mourey, Gabriel. *Les Arts de la Vie*, Paris, June and December 1904.

"A la Nationale." *La Revue Mondiale*, May 14, 1904.

L'Opinion, June 18, 1908.

La Patrie, April 22, 1906.

"Le Penseur de M. Rodin." *Le Chroniquer de Paris*, December 8, 1904.

"Le Penseur de Rodin." *L'Univers et le Monde* (December 30, 1904).

"Le 'Penseur' de Rodin." *Le Temps*, Paris, April 22, 1906.

Perrin, Henri. "Under the Hatchet." *Le*

Chroniquer de Paris, January 19, 1905.

Picard, Edmond. "Auguste Rodin, La Statue du Penseur." *Le Peuple*, Brussels, July 9, 1904.

Rod, Edouard. "L'Atelier de Rodin." *Gazette des Beaux-Arts*, May 1, 1898.

Rodin, Auguste. Letter to Marcel Adam. *Gil Blas*, July 7, 1904.

———. Letter to Mourey. *Les Arts de la Vie*, December 1904.

"Le Salon de la Société Nationale." *La Quinzaine*, Paris, May 10, 1904.

"La Salon de la Société Nationale." *La Quinzaine*, Paris, May 18, 1904.

Ségard, Achille. "Les Salons Annuels." *Echo du Nord*, Lille, May 8, 1904.

Symons, Arthur. "Notes on Auguste Rodin." *Apollo* 14 (1931).

Thiébault-Sisson. "Le Penseur de Rodin." *Le Temps*, Paris, December 2, 1903.

Ulla. *La Gueppe*, New Orleans, March 26, 1904.

L'Univers et le Monde, December 30, 1904.

V. "Notes Parisiennes." *La Liberté*, Paris, June 1, 1904.

Vauxcelles, Louis. *Gil Blas*, Paris, April 16, 1904.

Modern Criticism

Aldaheff, Albert. "Michelangelo and the Early Rodin." *Art Bulletin*, December 1963.

Butler, Ruth. *The Early Work of Rodin and Its Background*. Ann Arbor: University Microfilms, 1966.

———. *The Literary Aspects in the Work of Auguste Rodin*. Master's thesis, New York University Institute of Fine Arts, 1957.

———. *Rodin in Perspective*. Englewood Cliffs, N.J.: Prentice-Hall, 1980.

de Caso, Jacques and Patricia B. Sanders. *Rodin's Thinker*. San Francisco: Fine Arts Museums of San Francisco, 1973.

———. *Rodin's Sculpture: A Critical Study of the Spreckels Collection, California Palace of the Legion of Honor*. San Francisco: Fine Arts Museums of San Francisco

and Charles E. Tuttle, 1977.

Descharnes, Robert and Jean-Francois Chabrun. *Auguste Rodin*. London: Macmillan, 1967.

Elsen, Albert E., ed. *Auguste Rodin: Readings on His Life and Work*. Englewood Cliffs, N.J.: Prentice-Hall, 1965.

———. "Picasso's *Man With a Sheep*: Beyond Good and Evil." *Art International*, March–April 1977.

———, Stephen C. McGough, and Steven H. Wander, eds., *Rodin and Balzac*. Beverly Hills: Cantor, Fitzgerald, 1973.

———. *Rodin's Gates of Hell*. Minneapolis: University of Minnesota Press, 1960.

———. *In Rodin's Studio*. Ithaca: Cornell University Press, 1980.

———, ed. *Rodin Rediscovered*. Washington, D.C.: National Gallery of Art, 1981.

———. "Rodin's Sculpture for Sculptors." Yaseen Lecture, presented at the Metropolitan Museum of Art, New York, April 21, 1981.

Fusco, Peter and Horst W. Janson. *The Romantics to Rodin*. Los Angeles: Los Angeles County Museum of Art, George Braziller, 1980.

Geissbuhler, Elizabeth C. *Auguste Rodin: Cathedrals of France*: Boston: Beacon Press, 1965.

Grappe, Georges. *Catalogue du Musée Rodin*. Paris: Documents d'Art, 1944.

Gsell, Paul. *Rodin on Art*. Translated by Romilly Fedden. New York, 1971.

Janson, Horst W. "Rodin and Carrier-Belleuse: The Vase of the Titans." *Art Bulletin*, September 1968.

Judrin, Claudie. "Acquisition par le Musée Rodin d'une peinture de Munch." *Revue du Louvre et des Musées de France*, 1981.

———. *Rodin et les écrivains de son temps*. Meudon: Musée Rodin, 1976.

Merryman, John Henry and Albert E. Elsen. *Law, Ethics, and the Visual Arts*. New York: Bender, 1979.

Mower, David. "Antoine Augustin Préault (1809–1879)." *Art Bulletin*, June 1981.

Schmoll gen. Eisenwerth, J. A. *Der Torso als Symbol und Form: Zur Geschichte des Torso—Motivs im Werk Rodins*. Baden-Baden: Bruno Grimm, 1954.

———. *Torso—das Unvollendete als Kunstlerische Form*. Bern: Francke, 1959.

———. *Rodin-Studien*. Munich: Prestel Verlag, 1983.

Shroder, M. Z. *Icarus: The Image of the Artist in French Romanticism*. Cambridge: Harvard University Press, 1961.

Spear, Athena Tacha. *Rodin Sculpture in the Cleveland Museum of Art*. Cleveland: Cleveland Museum of Art, 1967.

Stalker, Douglas and Clark Glymour. "The Malignant Object: Thoughts on Public Sculpture." *The Public Interest*, Winter 1982.

Tancock, John. *The Sculpture of Auguste Rodin: The Collection of the Rodin Museum of Philadelphia*. Philadelphia: Philadelphia Museum of Art, 1976.

Thorson, Victoria. *Rodin's Graphics: A Catalogue Raisonné of Drypoints and Book Illustrations*. San Francisco: Fine Arts Museums of San Francisco, 1975.